Treasures in Trust

Treasures in Trust

Edited by A A Tait

Produced in association with the
National Trust for Scotland

EDINBURGH

HER MAJESTY'S STATIONERY OFFICE

Her Majesty's Stationery Office

Government Bookshops

13a Castle Street, Edinburgh EH2 3AR
49 High Holborn, London WC1V 6HB
41 The Hayes, Cardiff CF1 1JW
Brazennose Street, Manchester M60 8AS
Southey House, Wine Street, Bristol BS1 2BQ
258 Broad Street, Birmingham B1 2HE
80 Chichester Street, Belfast BT1 4JY

*Government publications are also available
through booksellers*

Acknowledgements

The National Trust for Scotland is indebted to Mobil North Sea Ltd,
the Director and Staff of the Royal Scottish Museum and the Scottish
Tourist Board for generously sponsoring this exhibition, which is
supported by this book.

David Learmont, who organised the exhibition, is most grateful to
the designer Paul Williams and to Messrs Beck and Pollitzer
Contracts Ltd. He also thanks the following most warmly; the staff
of the Stenhouse Conservation Office, Her Majesty's Stationery
Office, Messrs Whytock and Reid Ltd, Paul Couts Ltd, Francis
Bamford, Hugh Macandrew of the National Galleries of Scotland,
National Art Collections Fund, Scottish Heritage USA Inc.,
Edinburgh Festival Society, Leche Trust, Ardmore Fund, and to the
Studio and Curatorial Departments of the National Trust for Scotland.

Alan Tait is very much indebted to the photographers of the Royal
Commission on Ancient Monuments and to John Batty, Ernest J
Cook, Stewart Guthrie, Joe Rock, Tom Scott and Brian Swinburne.
Plate 8 is reproduced by gracious permission of Her Majesty the
Queen.

Designed by HMSO Graphic Design/J Cairns

ISBN 0 11 491745 0

Contents

List of Plates

1 William, 22nd Brodie of Brodie, and family, Brodie Castle.
2 Christina Leith-Hay, Leith Hall.
3 Leith Hall from the south.
4 Mary Leith, Leith Hall.
5 Jane Mackenzie-Fraser, Castle Fraser.
6 Castle Fraser from a watercolour by James Giles of 1862, Castle Fraser.
7 Lady Catherine Hamilton, Countess of Aberdeen, after Sir Thomas Lawrence, Haddo House.
8 Haddo House from a watercolour by the Hon. Mrs. A. Gordon.
9 Heraldic achievement in plasterwork at Craigievar from *The Baronial and Ecclesiastical Antiquities of Scotland*.
10 Castle Fraser from the south.
11 Crathes Castle from the west drive.
12 Craigievar Castle from the south west.
13 Kellie Castle from the south.
14 The tower at Drum Castle.
15 Drum Castle from the south.
16 The courtyard, Falkland Palace.
17 'Little Houses' at Dunkeld.
18 Greenbank.
19 The Garden Front, Haddo House.
20 The Blue Room, The House of The Binns.
21 The Saloon, The House of Dun.
22 Elevations of The House of Dun from *Vitruvius Scoticus*.
23 Charlotte Square.
24 Plan of Haddo House from *Vitruvius Scoticus*.
25 Culzean Castle.
26 The Picture Room, Culzean Castle.
27 The Burn wing at Brodie Castle.
28 The Library, Brodie Castle.
29 Brodick Castle.
30 The Drawing Room, Brodick Castle.
31 Threave House.
32 The Library, Haddo House.
33 Hill of Tarvit from the south.
34 The Hall, Hill of Tarvit.

35 The Kitchen, The Georgian House.

36 Carpets copied from originals at Haddo House.

37 The Dining Room, Kellie Castle.

38 The Saloon, Culzean Castle, during restoration.

39 Girandole from Culzean Castle.

40 The Drawing Room chimney piece, The Georgian House.

41 Gladstone's Land, during restoration.

42 Detail from a late seventeenth century crewel-work hanging, Falkland Palace.

43 Part of a suite of seat furniture from Castle Fraser.

44 One of twelve carved mahogany chairs worked with scenes of rustic card players, Culzean Castle.

45 Wing-back chair worked in cross-stitch, Drum Castle.

46 Side chair worked in a basket-work pattern, Drum Castle.

47 Mid-seventeenth century needle-work picture of Rebecca and Elizier, Kellie Castle.

48 Mid-eighteenth century pole screen with needle-work panel, The Georgian House.

49 Silver baton of the High Constable of Scotland, 1822, and two gold topped malacca walking canes, Brodie Castle.

50 Hilts of court sword c. 1760 (right) and hunting sword, 1733 (left), Drum Castle.

51 One of a pair of solid gold spurs, 1801, Castle Fraser.

52 Silver-gilt ostrich eggs ewers, 1866/67, Haddo House.

53 Mid-seventeenth century silver-gilt basin, Haddo House.

54 Late seventeenth century silver-gilt ewer, Haddo House.

55 Pair of thistle cups, Edinburgh 1692, Brodick Castle.

56 Group of candlesticks dating 1781, 1791 and 1817, Brodick Castle.

57 One of a pair of silver candlesticks, London 1841, Brodick Castle.

58 Pair of majolica candlesticks, a salt and a plate, Crathes Castle.

59 Pair of Meissen *bocage* candlesticks, Brodie Castle.

60 Chinese armorial ashet, 1773, The House of The Binns.

61 Chinese armorial porcelain tea tray, Drum Castle.

62 Chinese armorial soup tureen, Brodie Castle.

63 Tea-pot, teacup-and saucer, Derby c. 1815, The House of The Binns.

64 *Famille rose* goose tureen with silver mounts, Brodick Castle.

65 A porcelain bowl and cover with silver-gilt mounts, Brodick Castle.

66 The chairs of Alexander Burnett and Katherine Gordon, Crathes Castle.

67 Late seventeenth century marquetry cabinet, Crathes Castle.

68 Late Stuart lacquer cabinet, Brodie Castle.

69 Early eighteenth century silver table, Haddo House.

70 One of a set of late eighteenth century Venetian Blackamoor stools, Brodick Castle.

71 Late eighteenth century satinwood commode, Culzean Castle.

72 The Bachelors' Club, Tarbolton.

73 *Table à dessus coutissant* or 'bed table', Brodie Castle.

74 Cylinder desk by Wright and Mansfield, Haddo House.

75 *James VI as a Young Man*, Falkland Palace.

76 *Frozen River Scene*, Avercamp, Hill of Tarvit.

77 *Lord Haddo*, Pompeo Batoni, Haddo House.

78 *Mrs. Mure of Caldwell*, Allan Ramsay, Hill of Tarvit.

79 *Culzean Castle From the Sea*, Alexander Nasmyth, Culzean Castle.

80 *4th Earl of Aberdeen*, Sir Thomas Lawrence, Haddo,House.

81 *A Prize Fight*, Reinagle, Brodick Castle.

82 *A Cottage Scene*, David Cox, Brodie Castle.

Introduction

The National Trust for Scotland is distinct and independent of its English and Irish contemporaries. Such independence encourages its nationalism, and each of the following essays emphasise in its different ways a Scottish character. Art, like history, is developed rather than born, and the National Trust ensures as no other agency that the best and most typical is conserved and made relevant to contemporary society. Without a past, there can be no future. The National Trust for Scotland is the guarantee that that future will be rich and varied.

1931 was not a good year. In Scotland, the Depression had become a second Clearances where the land was not so much emptied of people as of a sense of history. Sheep may have eaten men, but lack of work eroded traditional values. For all that, 1931 was the year in which the Trust was born in Scotland, largely through the foresight of Sir John Stirling Maxwell. For him, the buildings, gardens and countryside of Scotland seemed to represent stable values in the debased currency of the thirties. The best vehicle for rescue appeared to be the English Trust, set up in 1894 with preservation and public access as its twin princples, which could easily be modified for the stonier paths of Scotland.

Any National Trust is a perpetual recipient. While it may play an aggressive role in the maintenance of its properties, such aggression is defensive. Its country houses, its burgh architecture, its acres of scenic mountain and loch, have all come to it as a sort of last hope or resort. Invariably, the Trust steps in where individuals and institutions seem blind, deaf or helpless. The appalling destruction of the ducal palace at Hamilton in 1927, more than anything else convinced Stirling Maxwell of the need for a Scottish National Trust. There was no time to be lost. Shortly afterwards, he wrote candidly of the country house and its owners; 'for the most part they are gone. Their houses are broken up, the treasures they contained have gone to other countries where they are better appreciated. Their woods which made the countryside beautiful have been felled'. His solution was not new laws or more money, but greater public concern, and in his book

Shrines and Homes of Scotland, of 1937, he repeated it. 'The only efficient protection', he wrote, 'against vandalism disguised as progress is to be found in an enlightened public opinion and such opinion will not come into play until the people of Scotland appreciate the beauty of their old buildings and their historical significance'. Hence the National Trust.

The essays which follow all celebrate the National Trust's country houses. They describe their silver, furniture, porcelain, hangings, and show their architecture from the sixteenth to the twentieth centuries. The picture they all give is of course a partial one – the inward view of some great country house rather than the vista over the gardens at Pitmedden, Culloden, or Ben Lawers.

Most of the Trust's country houses have come with some of their contents, though few with all. Such losses may be sad, as at Culzean, haunting as at Crathes, and inspiring for the historical reconstruction as at the Georgian House in Robert Adam's Charlotte Square. In some cases, the contents of the house still powerfully and profoundly express the taste of the family who owned them, as the Brodies at Brodie Castle. More exceptional is the impressive insight offered by the Brodick Silver into the imagination of the Regency connoisseur. The collection was formed by both the tenth Duke of Hamilton and his notorious father-in-law, William Beckford of Fonthill, and largely survived the Fonthill and Hamilton Palace sales to come to the Trust with Brodick Castle in 1958.

Few of the Trust's country houses overlap in either their contents or architectural style. Though both the Hill of Tarvit and Kellie Castle are Robert Lorimer buildings, each catch the architect in entirely different moods – the scholarly restorer at Kellie, the classical academic at Hill of Tarvit. As a whole, these country houses evocatively trace their own history, from the Snow White castles of Crathes and Craigievar to the more obviously domestic House of Dun, and the eighteenth century Gothic grandeur of Culzean. All of them bend and sway to a familial music of the times which continued, almost uninterrupted, until this century. The bond between Threave House of 1871 and its ruinous medieval namesake is a strong one.

Houses never remain at rest. The purpose of rooms change, some become more splendid like Brodie with its Great Exhibition carpet, others decline, fashions move restlessly on. Yet Scottish houses remain impressively, and impassively, conservative, reflecting not so much lack of imagination or diehard traditionalism, as a sympathy for the past. In this way, the nineteenth century rooms at Haddo were consciously in the William Adam style, Robert Adam's shades

called the tune at Culzean, and Lorimer sought a sixteenth century past for the interior of Kellie Castle. It was an ambiguous situation, so much so that at Leith Hall in 1860, its new chatelaine admired a room as 'a perfect gem, all new', while effectionately appreciating the 'dear old place . . . so quaint and cosy and old-fashioned and so cheery'.

These country houses and their contents are the history of Scotland, just as much as kings and battles and Factory Acts. They exemplify the beauty and historical significance that Sir John Stirling Maxwell saw as the fledgling Trust's duty to protect. How it has been done, where it happened, what has been lost, kept and restored, are the underlying themes of all these essays.

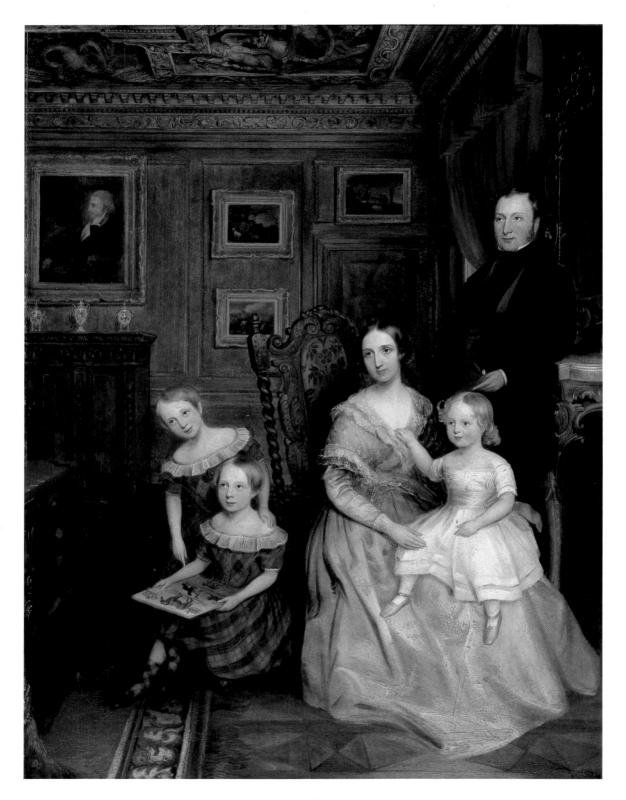

The Chatelaine

*I*n 1860, Alexander Sebastian Leith-Hay, brought his new bride, Christina Hamilton, to his ancestral home of Leith Hall in Aberdeenshire. (Plate 2) Clad in her 'going-away flounced lilac dress, Alick's Indian shawl, and travelling bonnet, clean gloves etc', Christina excitedly received the good wishes of more than four hundred people who had turned out to welcome her, then viewed with growing delight the house itself. As she told her mother and sister afterwards, it was charming: 'a dear old place, a great deal of what is old and nice and gentlemanly about it inside, and so quaint and cosy and old-fashioned and so cheery'. (Plate 3) Her own room was 'a perfect gem, all new, and has a pretty pale green carpet, lovely chintz on window and bed, seaweed on a white ground lined with pink' and, as a final elegant touch, a chimney piece 'edged with crimson fringe and handsome ornaments'.

Christina's enthusiasm was understandable. Many a castle or great house, set in its civilised parkland, its walls hung with rich tapestries and fine paintings, its silver and china laid out on handsome furniture, would seem to the modern observer to have been an idyllic setting for family life, a haven sheltering its occupants from the tribulations of the ordinary world. Yet the ladies who lived in these residences would scarcely have recognised this description and would probably have been quick to voice their complaints about leaking roofs, inconvenient kitchens and quarrelsome servants. The thoughts of the mediaeval chatelaine struggling to heat the chambers in the round tower at Brodick or organising a banquet at Kellie Castle have gone unrecorded, but they no doubt bemoaned their domestic difficulties as often as did their descendants.

It was true, of course, that they had a full complement of servants to help them, but almost all of these were men. The cook was a man, so were the steward, the butler and the caterer and then there were footmen, grooms and pages. The only women servants until the end of the seventeenth century were usually one or two gentlewomen, the children's nurses, the washerwoman and the henwife who looked after the poultry. The mistress of the household therefore took an

1 William, 22nd Brodie of Brodie, and family, Brodie Castle.

13

active part in its concerns, spinning wool and flax into thread for the weaver, making up bedlinen and napery from the cloth he sent back, sewing her husband's nightshirts and her own underclothes. Most estates were still virtually self-supporting, with cereals, eggs, butter, milk, cheese, meat and poultry coming in partly from the tenants as rents in kind. The lady of the castle usually inspected these supplies personally and it was she who ordered from town merchants such delicacies as hams, sweetmeats and, of course, wine. Ale was brewed under her supervision and when any of the family fell ill it was usually she who nursed them, often concocting remedies from the herbs she grew in her garden.

The tasks of the domestic sphere were always time-consuming and life could also be complicated by the conflicting personalities within the household. Many young couples began their married life together in the home of the bridegroom's parents and friction could all too often result. Lady Mary Kerr found this when she married Alexander Brodie's son James and went to live at Brodie. (Plate 1) A woman of spirit who knew her own mind and would stand up for her convictions, she took a violent dislike to her father-in-law and waged a running battle with him for nearly twenty years. On 19 June 1663, for instance, she was not on speaking terms with him and sent him a letter in which, he recorded resentfully in his diary, 'she shew that shee could not stay in the house if she wer straitend [limited] in her servants . . . and that her husband and shee had an unquiet life with me, and they could not bear it longer.' Probably just as tired of Lady Mary as she was of him, the laird was willing to grant her request that he should provide her husband and herself with accommodation elsewhere, but she never did move out, and fourteen years later was still arguing hotly with the old man, blaming his ill-temper over the accounts as the cause of her husband's recent illness.

Even more trying were the problems endured by Mary Hay of Rannes when her husband, John Leith, died after only six years of marriage. (Plate 4) Mary was left at Leith Hall with a young son and daughter to bring up and, unfortunately, her husband had made his own brother Patrick the children's guardian. According to Mary, he was totally unsuited for this responsibility. Not only was he 'a man of no religion and ane open blasphemer' but he was 'ane habituall drunkard, and that mostly by himself, without any other company.' Worse still, he allowed the cattle and sheep of the surrounding area to 'feed dayly in the parks where the young trees have been lately planted', thereby uprooting and destroying them. Mary even persuaded some of her neighbours to sign a petition against him, but it was in vain: Patrick continued to plague her with his presence at Leith

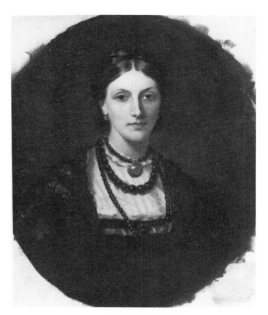

2 Christina Leith-Hay, Leith Hall.

3 Leith Hall from the south.

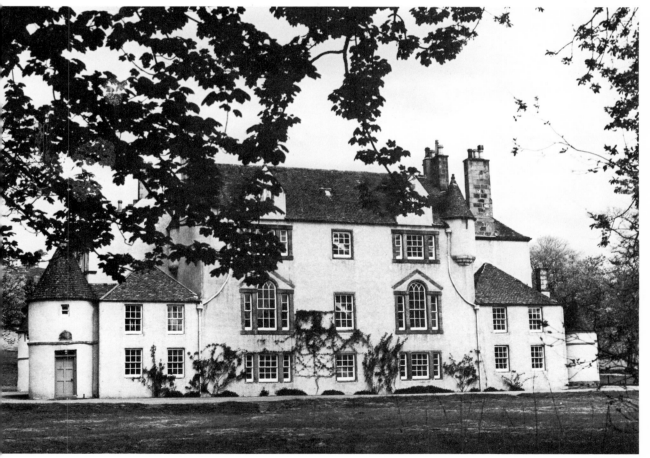

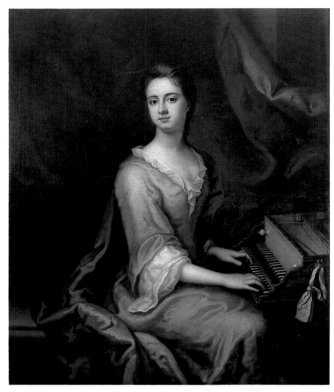

4 Mary Leith, Leith Hall.

Hall as the children's official guardian.

Family discord was disturbing enough, but even more alarming were the periods when warfare destroyed the peace of daily life. Until the late seventeenth century, ladies were still liable to find themselves defending their husbands' castles against besieging armies. In 1644, Lady Mary Gordon, wife of Alexander Irvine, was placed in a perilous situation at Drum Castle in Aberdeenshire. Her family were staunch Royalists and the Marquess of Argyll arrived at her gates with a Covenanting force, determined to take reprisals on them for their support of Charles I. Without a sufficient garrison, there was little Lady Mary could do. In the castle with her was her daughter-in-law who was Argyll's own niece, but this fact failed to undermine his resolution. As a contemporary reported, he 'shortly removed the two ladies and set them out of the gates perforce, with 2 grey plaids about their heads. The whole of the servants were also turned out. The ladies came, in pitiful manner, to Aberdeen, mounted on two work nags', whereupon the soldiers plundered Drum.

After the Restoration of 1660, times were more settled, and although the Lady Brodie of the day had both men and horses quartered on her house during the Jacobite Rising of 1745, inconvenience rather than direct danger was the result.

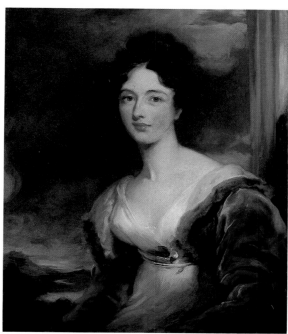

5 Jane Mackenzie-Fraser,
Castle Fraser.

6 Castle Fraser from a
watercolour by James Giles of
1862, Castle Fraser.

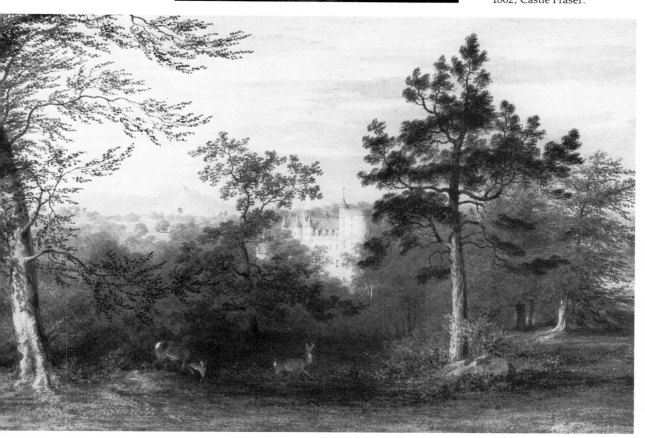

cannot understand the annoyances I went through during the year and a half we were last there . . . It entirely arose from not having a good maidservant . . . The discomfort of the house and knowing how wrong everything was going has always made me feel when I left as if a weight were taken off my mind and I could breathe freely.'

Much, of course, depended upon a lady's own outlook. As Elizabeth implied, many women went on running their households personally, while some families simply could not afford the town season. Even so, there were others who were compelled by convention to lead a life which they found both lonely and boring. They enjoyed the diversions of the town in winter, but languished in their country houses in the summer. Becalmed at Castle Fraser in 1820 when she was expecting her third child, Jane Hay, the wife of Colonel Charles Mackenzie-Fraser, wrote mournfully to tell her husband, 'I cannot live without you, dearest Charley, it must be confessed, at least it is a very dull sort of existence – I don't think ever widow felt as forlorn as I – but now I try to think of nothing but your return, and it is quite a sufficient subject to make me happy and lively and cheerful and everything I ought to be, to be worthy of you.' (Plates 5 and 6)

By then, life was changing for the lady of the household. No longer would she pass all her days in her country home. It was now becoming fashionable for aristocratic families to spend the winter season in Edinburgh or London where ladies engaged in an agreeable round of paying visits, going to balls, attending concerts and keeping appointments with the dressmaker. There was no longer any time for spinning or purchasing food or making up herbal remedies. Indeed, domestic work was regarded with some disdain as an entirely unsuitable pursuit for the lady of fashion. A female housekeeper now took over the domestic managment, with a fleet of chambermaids, laundry maids and housemaids to do her bidding.

This new attitude of mind is very well illustrated in the correspondence of Elizabeth Brodie. Formerly the wealthy Miss Baillie of Redcastle, she married William Brodie in 1688, then proceeded to ply him with constant complaints. In one telling passage in a letter written from Belgium ten years later, she urged him to find 'a really good, respectable housekeper', explaining that 'our comfort will depend so very much upon the one we get.' She went on, 'We must have one who has experience in the management of a country house, as I don't pretend to be an upper servant, which most of the ladies about us are, tho they don't made good ones, judging from their establishments [and] cuisines.' Less than a fortnight later, she returned to the attack, telling her long-suffering husband, 'You who do not interfere with the house

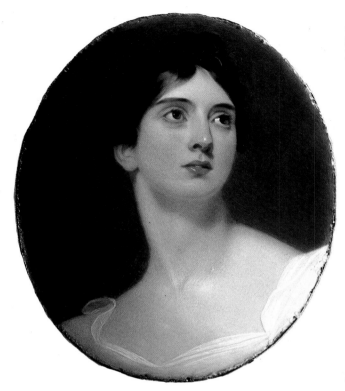

7 Lady Catherine Hamilton,
Countess of Aberdeen, after
Sir Thomas Lawrence, Haddo
House.

8 Haddo House from a
watercolour by the Hon. Mrs.
A. Gordon.

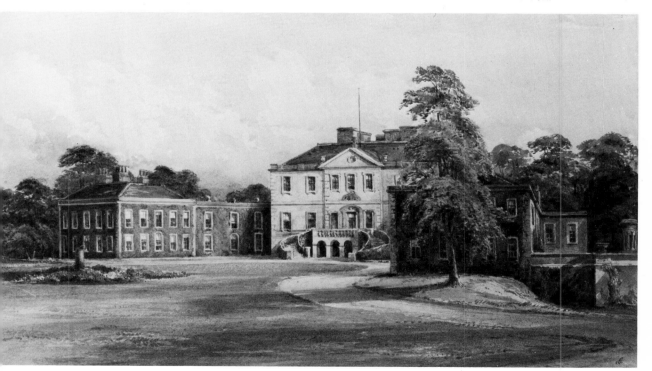

Jane's condition was no doubt the cause of her depression but some town-bred ladies undoubtedly suffered very real despair at the prospect of long hours of leisure in a country house. Many others, however, were ready to adapt themselves to circumstances, as Lady Catherine Hamilton did in 1806. The daughter of the 2nd Marquess of Abercorn, she was a proud, sophisticated young woman, one of the beauties of the Court. A year after her marriage to the 4th Earl of Aberdeen, she set off to visit her husband's ancestral home for the first time amidst dire warnings from family and friends as to the inconvenience of Haddo House and the inhospitability of the surrounding countryside. (Plate 8) Even her own husband had been discouraging. He himself had stayed at Haddo the previous year, making his first visit since childhood, and he had found the house dilapidated and depressing. Not so Lady Catherine. 'Dear Papa', she reported with delight soon after her arrival, 'You need not believe one word of what Lord Aberdeen says about this place, for I assure you that there is nothing to complain of. I never was so surprised in my life as when I first saw it, for I had been told so much about it by everybody that I had expected a thing not fit for a human being to live in, placed in the middle of a barren, bleak moor without a tree or anything near it'. Instead, the countryside was wooded and pleasant and the house itself cheerful. 'With a good chair and sopha or two and new curtains to the drawingroom, I do not wish for anything better', she declared. In this spirit of determination and good sense, women throughout the centuries were able to overcome the domestic inconveniences and appreciate the pleasures of life in an historic house.

ROSALIND K. MARSHALL

Further Reading

Marion Lochhead, *The Scots Household in the Eighteenth Century* (1948)
Rosalind K Marshall, *The Days of Duchess Anne* (1973)
Rosalind K Marshall, *Catalogue, Women in Scotland 1660–1780* (1979)
Marjorie Plant, *The Domestic Life of Scotland in the 18th Century* (1952)
John Warrack, *Domestic Life in Scotland 1488–1688* (1920)

The Castles of Mar

Among all the possessions of the National Trust for Scotland surely the most inherently Scottish must be those lairds' houses which reached their fruition in the early 17th century with that group in the fertile lands of the north-east, Castle Fraser, Crathes and Craigievar. By any standards they represent a considerable aesthetic achievement, attained almost without outside influences but springing directly from the conditions and processes prevailing in Scotland over the years leading up to their construction. It is a story which can be traced, in all its essentials, within the properties now in the care of the Trust.

It was Vitruvius who first laid down the three qualities necessary for Architecture if it was to be worthy of the name, qualities translated into English just about the time that this Scots style was at its peak as 'Firmness, Commoditie and Delight.' Certainly these qualities are to be found in much of the Scots 17th century style and these three houses in particular.

In the matter of 'Firmness', or structural skill, this was largely the outcome of the nature of the countryside, rich in good stone but almost poverty stricken for structural timber so that all the techniques of the former were extended to reduce the need for the latter. So uncompromisingly stone-built are they that sometimes these houses seem almost to reach the frontier between architecture and sculpture

Both the timber shortage and the skills readily to hand led to an emphasis on height and for 'Commoditie', or functional requirements, the masons' skills were again put to the test to provide all the accommodation required for the social and domestic life of the time within the narrow confines of a tower, thus reducing the area to be roofed over and hence the need for timber. Not the least fascinating part of a visit to one of these houses is the way they speak to us of the life that went on in them and to trace out the ingenuity with which the Great Hall, the various rooms, common and private, the spiral stairs and closets were organised and worked together within such restricted limits.

Happily an emphasis on height and the castle image, derived from the architecture of defence in which the tradi-

tional masons' craft had been learnt, though no longer having any practial significance, played an important part in the third quality of 'Delight'. As always, this meant the expression in outward form of the ideals and aspirations of those who caused them to be built. Here a pointer of great significance is to be found in the heraldic displays which these houses carry. The uppermost, the largest and the most splendid are not, as might be expected, the family coat-of-arms but the Royal Arms of Scotland, exemplified by the great frontispiece high on the north facade at Castle Fraser and the plaster representation over the Hall fireplace at Craigievar. (Plate 9) It was in this role as representative of the king's authority that each laird saw himself in his own area, holding his lands directly of the Crown without any other feudal intermediary and, through his Heritable Jurisdiction and Baron Court, administering justice and providing the leadership and authority over the area and community around. For this the architecture of strength, handed down from the old military fortresses, came to be modified into the

9 Heraldic achievement in plasterwork at Craigievar from *The Baronial and Ecclesiastical Antiquities of Scotland*.

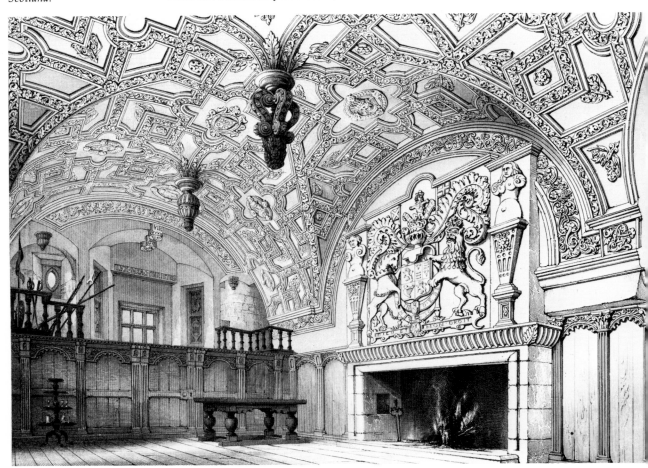

cap-houses, turrets and corbelling of the Scots baronial style. This view of the laird's house as the seat of authority is admirably summed up in a letter of advice written in 1632 by Robert Kerr, Earl of Ancram, to his son William, Earl of Lothian, regarding an old house in the Borders which the latter was proposing to modernise. His father wrote, 'By any means do not take away the Battlement, as some gave me counsel to do, for that is the grace of the house, and makes it look like a castle and hence so noblest.'

Nothing would be gained by trying to assess which of the three, Castle Fraser, Crathes or Craigievar, most perfectly incorporated the three vital qualities into the Scots idiom. Each has its own distinctions.

Castle Fraser can claim to be the oldest of the three in origin. (Plate 10) It started as a simple rectangular tower, typical of the 15th century, with battlemented crest, probably not unlike that surviving at Drum Castle, another Trust house near the banks of the Dee. Then, over the years between 1575 and 1663 and through two generations, the original

10 Castle Fraser from the south.

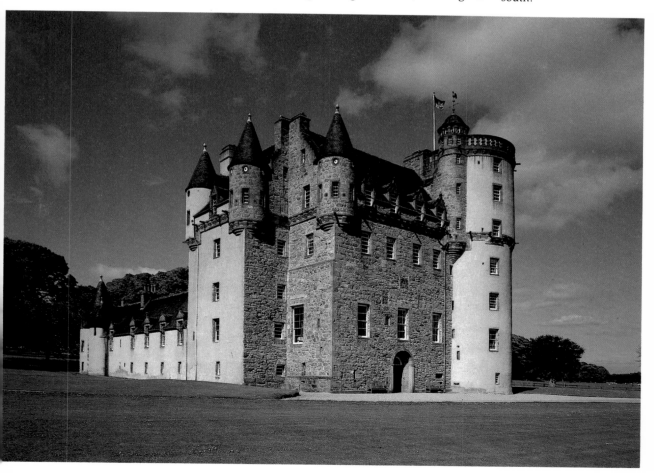

tower was added to and finally completely submerged in the much enlarged and heightened building we have to-day. These additions and changes vividly reflect, not only the growing status and influence of the Fraser family, but also the way in which social attitudes and customs were changing at that time. In the form we have it to-day, as well as being the largest and most complete with its long wings of service quarters, the great round tower and the high frontispiece of the Royal Arms, already mentioned, combine to make it the most majestic of the three.

Crathes was being built, with long interruptions, throughout the whole second half of the 16th century. (Plate 11) While well up to standard architecturally with the others, its chief claim as a Treasure in Trust must surely rest on the painted decoration dating from the very early years of the 17th century. This was a craft which a change of fashion doomed to extinction very soon after. Alexander Burnet, who commissioned it, luckily caught it at its final high water mark. It was not an exclusively Scottish craft but one that Scotland shared with the countries of Scandinavia and the Baltic, reminding us of the flourishing trade between Scotland's east coast ports and those countries, not least in the import of the timbers required for construction and on which these paintings are carried out. These ceilings in their original setting are indeed one of the Trust's treasures, not only for themselves, but also as evidence of the brilliantly coloured background to domestic life in Scotland in those days, so different from the dour barrenness of much popular misconception.

Mention of the Scots trade across the North Sea brings us to Craigievar, for it was the wealth derived from that trade which provided the funds for its construction. (Plate 12) The castle had been started by the old established family of Mortimer, but they had to sell out in 1610 when it was yet only half built and it was bought in this state and completed by William Forbes. So renowned was he in Aberdeen as a shipping merchant and so prosperous did he become that he was known as 'Danzig Willie'. He died in 1627, just one year after completing Craigievar, but before his death he had created what must surely be regarded as the epitome of the truly indigenous Scots architecture. It is a building expressing the essence of the granite of which it is built, containing all the requisite accommodation with an effect of spaciousness within which seems irreconcilable with the narrow confines of the exterior. The rooms are decorated with the moulded plasterwork newly introduced from England, here culminating in the great Royal Arms of Scotland over the Hall fireplace.

In its external form Craigievar stands as a marvellous

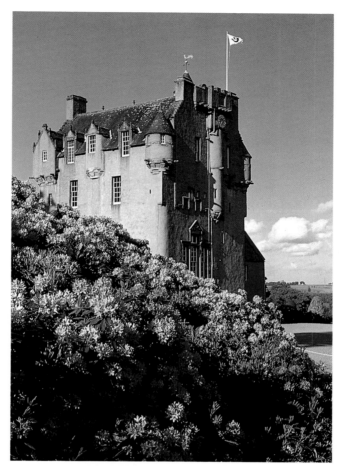

11 Crathes Castle from the west drive.

12 Craigievar Castle from the south west.

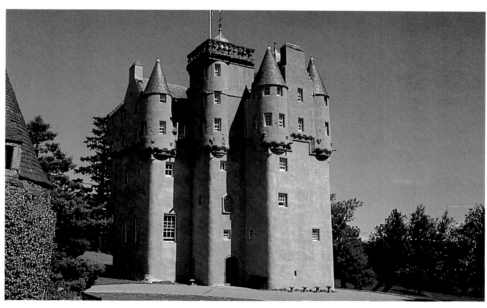

artistic achievement by any standards. It has a three dimensional quality few buildings can rival. There are no formal facades but as one moves around it the eye is constantly drawn to the way each grouping of wall faces, curves, gables and turrets leads on and merges into the next. The whole has most justly been compared to some great tree trunk in the way it seems to thrust up out of the ground, yet with every sturdy line of it the very embodiment of the Scots motto, *Nemo me impune lacessit.*

But these three do not stand alone. The Trust has other examples of the truly indigenous Scots style in its care. They may not have quite the same architectural panache but none the less have much to say of the way of life, the personalities and the achievements of those who created them. For this reason, if no more and quite apart from their contents, many of which are exhibited here, they stand to be numbered among the country's treasures.

There is Brodie Castle for instance, the most recently acquired and, to date, the most northerly of such places. Its

13 Kellie Castle from the south.

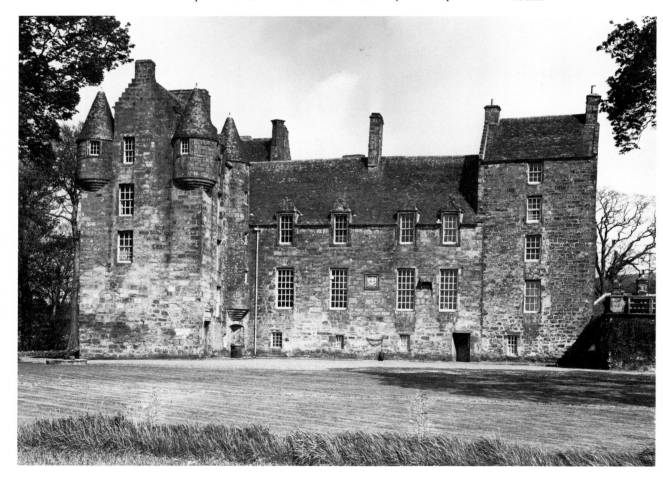

14 The tower at Drum Castle.

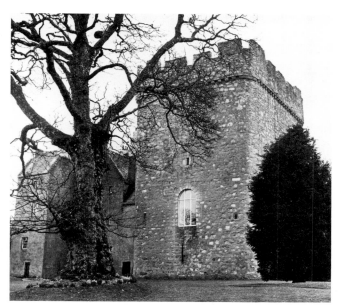

15 Drum Castle from the south.

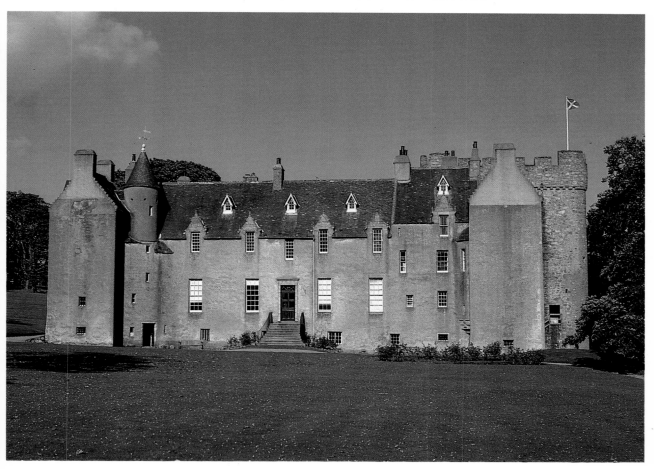

history in the hands of the Brodie family goes back to the 12th century. The present house is in two quite distinct parts, the older dating from the 16th century and very typical of that period in form, but now partly masked by early 19th century extensions. Over the years the family have gathered together a very fine art collection of furniture, porcelain and pictures, but about the year 1670 the laird installed one treasure which cannot be brought to such an exhibition as this, a most elaborate and richly ornamented plaster ceiling in his chamber-of-dais, a remarkable *tour-de-force*.

The building of Kellie Castle in Fife seems to have been somewhat piecemeal, but both the traditions for a laird's house and his domestic requirements were firmly established and the outcome is again entirely true to type. (Plate 13) Conveniently close to the east coast ports timber presented less of a problem and the entry tower at the south west corner is linked to the private tower to the east by a fairly long central block containing a splendid hall and chamber-of-dais all on one level. The latter room has panelling put up

16 The courtyard, Falkland Palace.

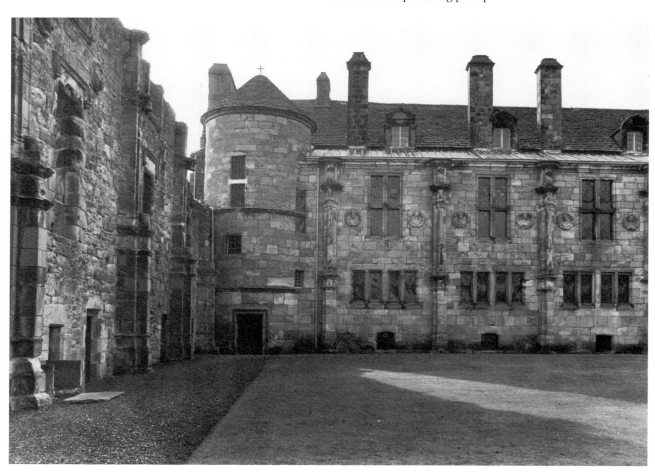

in the time of Charles II and decorated with little imaginary painted landscapes and there are several fine ceilings of decorative plaster work.

And so back to Drum Castle where the old 14th century tower illustrates the origins of the Scots tower house style and where the new house (for that it was rather than an extension) shows the end. (Plate 14) The masons' craft remains, the domestic requirements and lay-out are unchanged, but now the castle image has gone and the emphasis on height has given way to the first signs of a horizontal symmetry foreshadowing things to come. (Plate 15)

There remains one more building not yet mentioned, the Palace of Falkland. (Plate 16) As a royal residence this comes into quite a different category. Here the keynote was 'Splendour' rather than a self-sufficient independence. Both the outlook and the resources had a far wider scope than were to be found among the king's subjects and the native stock of materials and craftsmanship could be and were supplemented from abroad. James IV and James V were responsible for most of what survives to-day and both employed French craftsmen. The result is indeed splendid, incorporating two of the earliest Renaissance facades surviving to-day in Britain. For some time the royal example made very little impression outside. It was not until the settlement after the Civil War opened up the way that these new ideas came flooding up from the south. Among the casualties in that struggle must be numbered the truly indigenous Scots architecture.

W. SCHOMBERG SCOTT

Further Reading

Stewart Cruden, *The Scottish Castle* (1963)
John Dunbar, *The Historic Architecture of Scotland* (1966)
David MacGibbon and Thomas Ross, *The Castellated and Domestic Architecture of Scotland* (1887), 5 vols
Douglas Simpson, *Scottish Castles* (1959)

Eighteenth Century Buildings

The character of Scottish architecture at the opening of the eighteenth century is probably best conveyed by language that stresses its robustness, its doughty quality and its practical good sense. It may indeed be wrong to talk about architecture at all, for much of Scottish building until well beyond the mid-century is in a vernacular, unselfconscious idiom where considerations such as sound construction and economy of materials dictate the appearance of what is built. This is true of Scottish towns and villages, of churches, and, as often as not, even of the new mansions built on country estates. We might describe an early Georgian country house in Scotland as being handsome: meaning that it is large, regular and well-built but even when its designer consciously attempts an architectural display the effect will rarely be elegant.

By 1770 a new refinement appears: the New Town of Edinburgh – Princes Street, George Street and Queen Street – had been begun; regular facades were building in Glasgow and Aberdeen and soon, throughout the countryside, plans for ideal villages had been projected or built. The earliest of these is at Inveraray about 1750 to be followed by Fochabers, Monymusk and Ullapool and schemes for the Citadel at Ayr, Ardrossan and Dunninald. By the latter part of the century architecture is generally more calculated and more refined. Robustness does not disappear but it is moderated by finer profiles and a universal taste for delicacy that is as marked in furniture, silverware and dress as it is in timber and stone. The carefully balanced interior decorations of the Adam style must represent the apogee of this quest for elegance yet, even as it is established, a new and distinctly different taste begins to appear in which native robustness has certainly a role. Romantic notions of nationality, or picturesque theories about the aesthetic appeal of ruins lie behind the new style, in the development of which Robert and James Adam play a considerable part. As the century draws towards a close, a country house, a gate lodge, a home farm or even a church may be designed in a Neo-medieval, non classical style which acknowledging a different scale of values, borrows its forms from fortified buildings or from Gothic

abbeys. The Adams erected sixteen such buildings and after 1800, following this example, Romantic houses largely supplanted their classical pre-cursors, becoming the norm in picturesque situations where their varied silhouette added dramatic force to the wilder and more rugged tracts of the Scottish landscape. Classical villas were, by the early nineteenth century, increasingly confined to pastoral settings or to the immediate vicinity of towns.

Beside these stylistic considerations, what gives a remarkable homogeneity to the eighteenth-century buildings of the Scottish countryside or to minor towns – Anstruther, Dunkeld or Kirriemuir – is the absolutely consistent use of stone as a building material. (Plate 17) Scotland is unusually fortunate in its wealth of good building stone. It has firmly textured granites in Dumfries and Galloway and in the Highland and Grampian regions, and it has a variety of excellent sandstones from silver-grey Ravelston and pale-biscuit Craigleith – both familiar in the New Town of Edinburgh – to the plum-pink and reds of the South West, the yellow of the Clyde valley or the tans and browns of Inverness. Centuries of skill go into the working of these stones but as granite is not easily cut and as many sandstone walls are porous the most common finish in the eighteenth century, as in the seventeenth, is a protective rough coat of plaster, known as harling. Normally in the Georgian period a Scottish mason formed a frame or border of dressed stone round doors and windows, at the eaves and on the coping stones of gables. The harling was then spread evenly over the rest of the wall. Many of the minor eighteenth-century properties

17 'Little Houses' at Dunkeld.

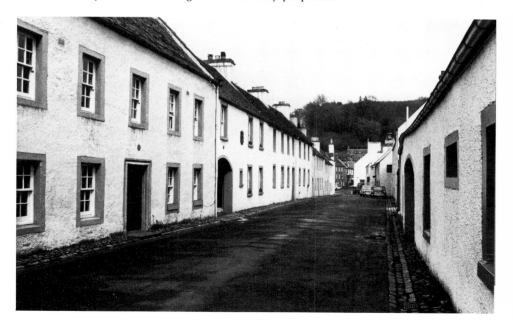

31

in the care of the Trust are harled in this way and so also are the Georgian additions to Leith Hall in Aberdeenshire of 1756 and 1797, the beautiful curved stable block there, and the delightful mid-Georgian suburban villa of Greenbank built at Clarkston near Glasgow in 1763. (Plate 18) Several eighteenth-century mixtures for harling are known from which it is clear that the subtle tints of colour that distinguished different properties or estates were achieved by such simple means as mixing powdered brick, horse urine or cowdung with the plaster.

If harling was not used, vernacular or estate buildings were usually built with rubble walls of roughly squared stones. In the granite districts this gives rise to a very characteristic coursed rubble walling where large rectangular blocks alternate with vertical dashes of three or four smaller stones. This technique of walling even appears on the aristocratic garden front of Haddo House in Aberdeenshire though it is here accompanied by a display of corner quoins, cornices and string courses. (Plate 19) More self conscious designs often make use of different stone surfaces to contrast ashlar work, the most expensive smoothly polished finish often reserved for the centre part of a composition, with rubble or harled wings, or in the work of the Adam brothers with a type of horizontal tooling known as 'broached or droved work' which is much employed at Culzean and on their other castles. As the century advances a perfectly built ashlar facade, at least on the main front of a house, becomes more common while, as part of the same development, a more refined, though less practical, treatment of the eaves of roofs replaces the exposed gutter of early Georgian designs, first by a balustrade, later by a low stone parapet such as Haddo gained about 1828, or by a blocking course such as Robert Adam used at Charlotte Square, or finally by the battlements or pinnacles of Gothic and Castle designs.

The interiors of country houses in Georgian Scotland reflect the same general shift from robust comfort, first to greater enrichment, then to elegance and restraint. Window openings become larger and, are sometimes carried down to floor level, as in the saloon at Culzean, instead of stopping at the height of the chair rail. After about 1780 window reveals begin to be splayed, as side-drawing curtains come into fashion, and the glazing bars of the sashes also change from heavy serviceable divisions into thin sections of timber which require no more than a narrow half-round Greek moulding – an astragal – to decorate their interior face. This change may be remarked on Trust property, by comparing the mid-Georgian sashes installed in the seventeenth-century front at Malleny, Midlothian, with the windows of the diningroom and drawingroom extension of 1810.

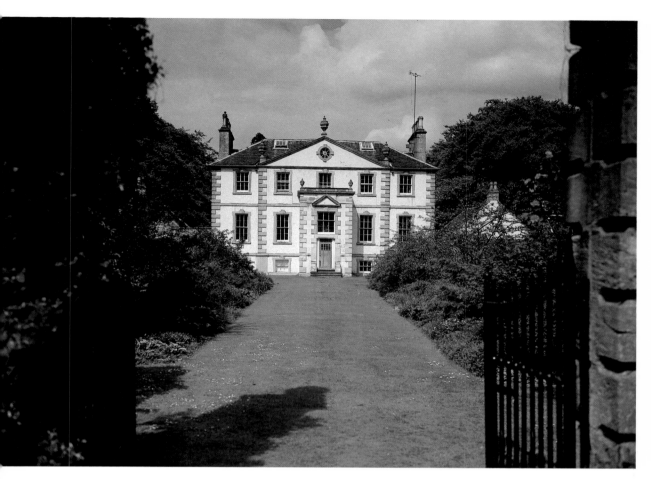

8 Greenbank

9 The Garden Front, Haddo House.

For the first quarter of the century main rooms were usually panelled with timber wainscotting. The earliest style, surviving from the late seventeenth century had projecting panels brought forward on bolection mouldings, as in the Blue room of The Binns. (Plate 20) These were followed by a design, characteristic of the early Georgian period, where the panels are smaller and are set flush with the wall with shallow bevelled edges which are copied in the doors and shutters. Wainscotted rooms give place by about 1730 to walls decorated either with plaster panelling, which was thought to be less of a fire hazard, or else, for rooms of state, with damask. The designs employed in Scottish plasterwork seem, until the Adam 'revolution' of the 1770s, to have been left largely to the plasterers' own invention. They move from a staid geometrical style, in which lugged frames and some deeply moulded accents – such as masks or garlands – are dominant, to free and richly decorated schemes where leafy branches, ribbons, scrolls, swags or net-work fill any area not occupied by figural scenes. From about 1740 to 1760

20 The Blue Room, The House of The Binns.

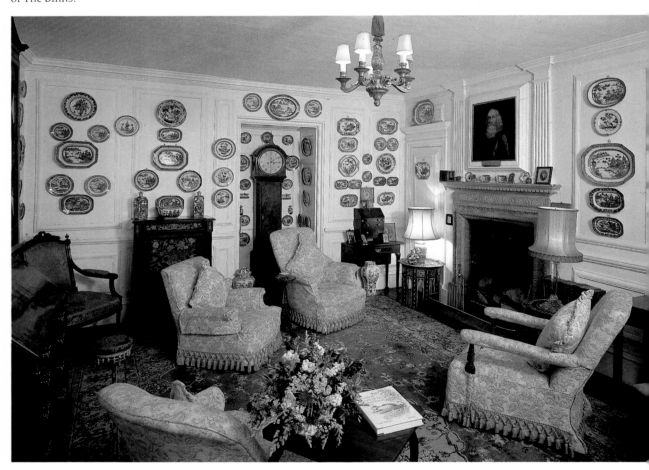

34

the classic setting for such a display is the high coved ceiling favoured by architects for saloons, staircases or halls. The men whose names have come down to us as the principal creators of these Rococo schemes are Joseph Ensor, who worked at Dun House, William Clayton and George Morrison. (Plate 21) The advent of a more 'Antique' taste reduced the plasterer's role from that of an artist to a skilled artisan. Architects now drew out their own designs in detail and in these the mouldings – like the window glazing bars – became thinner and the figural panels smaller and lower in relief. The end of plasterwork as an art form comes in the early nineteenth century when the material is reduced to the status of a cheap substitute to imitate stone vaults or corbel stops in the corridors and staircases of late Georgian Gothic houses. In the most elaborate of these, Taymouth Castle in Perthshire, the spectacular ceiling of the stair tower is a replica of the fan vaulting at the crossing of Canterbury Cathedral executed by the London-based Italian, Francis Bernasconi.

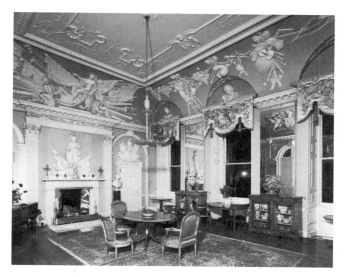

21 The Saloon, The House of Dun.

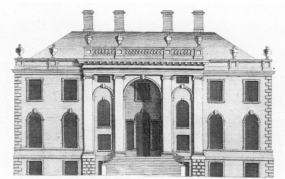

22 Elevation of The House of Dun from *Vitruvius Scoticus*.

Two agents effected these changes in Scottish taste: on one hand there was the example of published architectural pattern books which offered modern models that might be adapted to Scottish needs; and on the other there were the Scottish architects themselves. Of the books none was more influential or in wider circulation than James Gibbs's *Book of Architecture* of 1728, the Palladian Isaac Ware's *Complete Body of Architecture* of about 1756, and Robert and James Adam's *Works in Architecture* of 1773. A wealth of motifs borrowed either by known architects, or adopted in anonymous designs, attests the widespread influence of these books. There were of course many others, such as the five volumes of *Vitruvius Britannicus* of 1715–1771, or Sir William Chambers's *Treatise on Civil Architecture* of 1759, to keep proprietors and burgh councils abreast of architectural developments.

Among the architects no one played a more vital role than William Adam of Blair Adam and his sons John, Robert and James. To a quite extraordinary degree, this one family of

23 Charlotte Square.

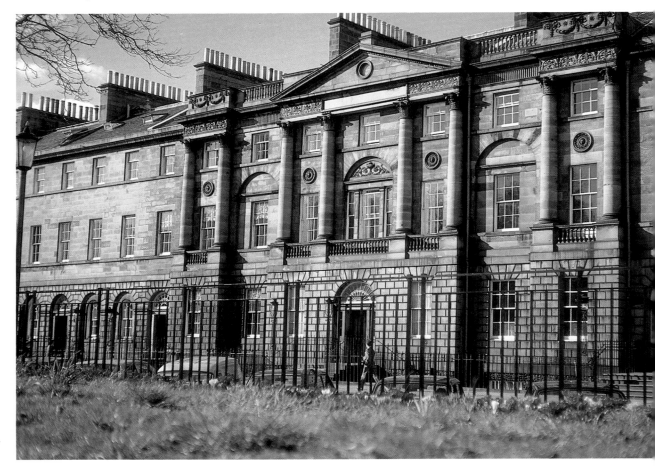

architectural entrepreneurs dominates Scottish eighteenth-century building from William's rise in the early 1720s to the deaths of the younger brothers in London, Robert in 1792 and James in 1794. Thus it is that the three great country houses of the Georgian period which belong to the Trust are all Adam designs. Two are by William: Dun House in Angus, built between 1728 and 1730 for David Erskine, a law lord of the Court of Session, and Haddo, erected by the second Earl of Aberdeen between 1732 and 1735. (Plate 24) The third is Robert and James's extraordinary castle-style house, Culzean, set on an Ayrshire cliff and developed at the whim of David Kennedy, tenth Earl of Cassilis, a cultivated bachelor like the brothers themselves, who began the house in 1777 and only completed it in 1792, the year of his death. To these country houses may be added the incomparable Neo-classical facades of Charlotte Square, Edinburgh, designed by Robert in 1791, where the Trust now has its headquarters at No 5 and has opened No 7 as a Georgian Town House. (Plate 23)

As a group the four Adam structures conveniently

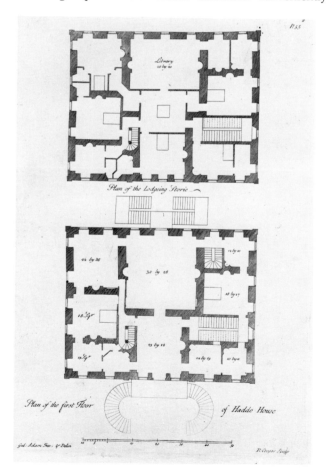

24 Plan of Haddo House from *Vitruvius Scoticus*.

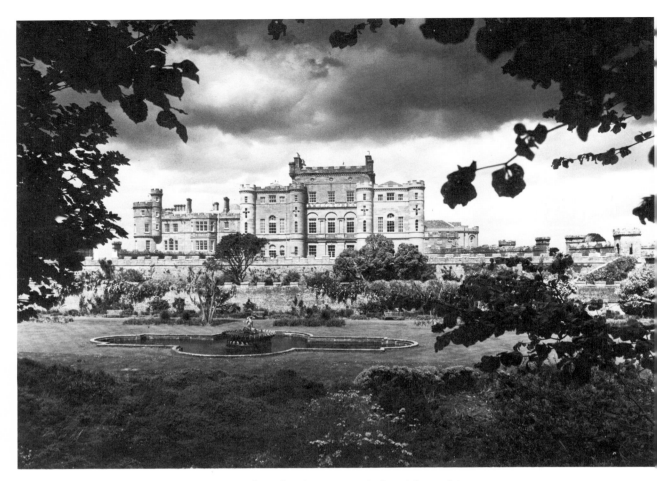

25 Culzean Castle.

summarise the development of Scottish architecture throughout the eighteenth century. Dun House which was adapted by William Adam from a design prepared by the Jacobite Earl of Mar, looks back in some respects to the restrained Baroque models of Sir William Bruce and James Smith. Window proportions and the play of round arches on the main front are reminiscent of continental models, while in the curved interior corners of the entrance hall a typical Lord Mar and Smith motif appears. Haddo by contrast is a provincial Palladian house, typical, in its massing and in the disposition of its flanking wings, of many early Georgian schemes though less sophisticated than the later work in this taste by Ware at Amisfield, East Lothian, of 1756; by John and James Adam at Paxton, Berwickshire, of 1758 or by Sir James Clerk and John Baxter at Penicuik, Midlothian, of 1761. (Plate 24) Culzean represents another change in taste marking, in many respects, the culmination of Robert and James Adam's study of romantic castle architecture which attempts to revive both the grandeur of antique fortification

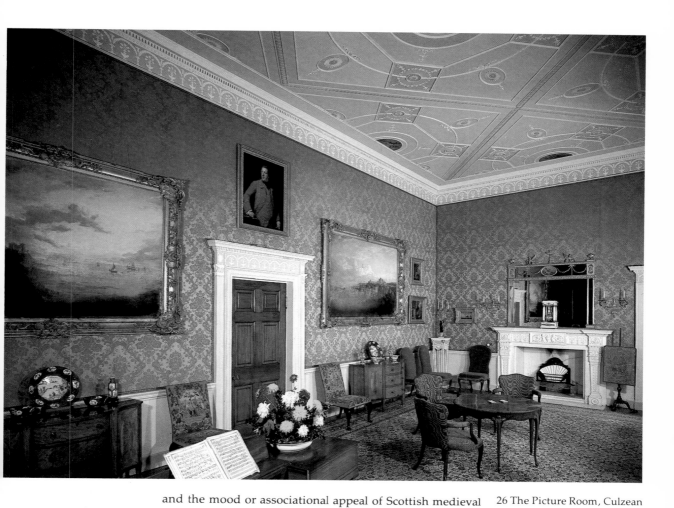

and the mood or associational appeal of Scottish medieval buildings. (Plate 25) Its interior, recently revitalised in a coherent programme of historical restoration offers one of the most complete examples of the range of the brothers' Neo-classical decorative style from the heroic scale and drama of the central oval staircase to the delicate opulence of the damask picture room. (Plate 26) A similar rich taste informs the elevations of Charlotte Square yet this refined Roman style was hardly to survive its authors' deaths.

26 The Picture Room, Culzean Castle.

ALISTAIR ROWAN

Further Reading

Howard Colvin, *A Biographical Dictionary of British Architects, 1600–1840* (1978)

John Dunbar, *The Historic Architecture of Scotland* (1966)

John Fleming, *Scottish Country Houses open to the Public* (1958)

James Macaulay, *The Gothic Revival, 1745–1845* (1975)

James Simpson (ed.) William Adam, *Vitruvius Scoticus* (1980)

The Revival Styles

At first sight the nineteenth century might not seem well represented in the Trust's holdings. It does not possess any notable burgh architecture of that vintage and its aim of completing the sequence of correctly furnished town houses with a Victorian example has yet to be realised. But amongst the Trust's castles and country houses, even although only one was built anew, the work of most of the more important domestic architects of late Georgian and Victorian times will be found, presenting an unusually interesting variety of response to changing tastes and changing patterns of living.

The Romantic revival did not at first encompass the native Scottish architecture of the sixteenth and seventeenth centuries and it had a long hard struggle over nearly forty years to fully re-establish its identity. In the early years of the century its robust qualities were appreciated only by a few discerning antiquaries; most of the landed gentry had formed their ideas of antiquity from English publications and were in any event concerned to have houses which would be recognised as being in the best contemporary taste south of the border. Thus the London architect George Saunders's scheme for modernising Scone Palace in its own Scots Jacobean idiom came to be passed over in favour of William Atkinson's executed English gothic design (1803) which set the style for the few years before the largely self-trained Scot James Gillespie Graham (1776–1855), then just Mr Gillespie, introduced us to an equally English castle style in a series of houses beginning with Culdees in Perthshire about 1810, all basically similar with conventionally symmetrical plans given a dominant asymmetrical element by the addition of a machicolated drum tower at one end. When such a tower either could not be afforded, or was perhaps not appreciated by the client, the main block tended to remain frankly symmetrical.

The remodelling of The Binns, the first of the Trust's houses to be brought into conformity with the Gothic taste, belongs to the latter category. Although the kitchen yard elevation suggests Gillespie's hand, it has not yet been possible to document the work done there, plausibly dated

to *circa* 1810 although the matching tower on the adjoining hilltop is dated 1826, and if we assume Robert (1752–1815) rather than his son William, the Dalyell tradition that the work was designed by Burn may be correct since the elder Burn designed some rather similar work for Saltoun in 1803. Without any great modification of its plan, and fortunately without any disturbance to its plasterwork, this seventeenth century courtyard house, already turned round to enter from the north *circa* 1740, was rewindowed and slightly re-arranged as a near-symmetrical plain Tudor pile crowned with ashlar crenellated parapets to screen its old fashioned high roofs, a touch of Regency elegance being provided by the slim cast-iron entrance colonnade and continuous first floor balcony, since regrettably removed.

At Culzean, where the castle was only recently completed, work extended into the embellishment of the grounds. Gillespie Graham was among those consulted and may possibly have been responsible for the perpendicular gothic Camellia House; the London architect Robert Lugar (c. 1773–1855) who had designed two castles on Loch Lomond side, of which Balloch remains, was responsible for the octagonal Swan Cottage and the associated pilastraded aviary. The former well exemplifies the fashion for low-proportioned cottagey buildings with broad eaves and fretted valances which his publications, and others, had made popular from 1805 onwards, the latter a continuing fashion for mixed classical and gothic motifs. Lugar himself evidently thought well of it since he illustrated it in the second edition of his *Plans and Views*, published in 1823.

Lugar is of particular interest in a Scottish context as the architect with whom that subtle and brilliant master of Neo-classical design, Archibald Simpson (1790–1847) of Aberdeen, completed his professional training. Simpson's finest surviving classical houses are the Greek Doric Crimonmogate (c. 1825) in Aberdeenshire and the grandly Corinthian Stracathro (1828) in Angus, but the updating of the Trust's Haddo for the 4th Earl of Aberdeen well illustrates his skill in a lower key, particularly at the new external stair on the east front where the subtle gradations of diluted ink in his elevation were made real in the executed work. Within he mitigated 'the appalling badness' of the interior by a new stairhall with a rich coffered ceiling, and it was probably he who brought the proportions of the main block more in line with contemporary taste by adding parapets so that it showed rather less roof. Twenty years later the increased sophis-tication required in the servicing of such houses caused the same Earl to call in Simpson's rivals, John Smith (1781–1852) and his son William (1817–91) of Balmoral fame to enlarge the service court, since rearranged. The Smiths are better

27 The Burn wing at Brodie Castle.

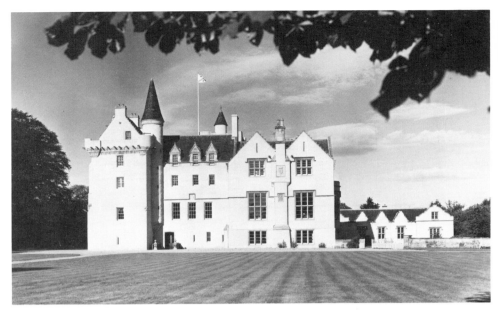

28 The Library, Brodie Castle.

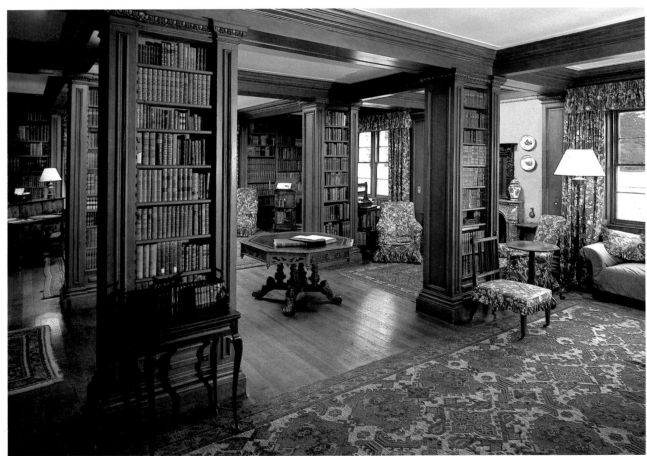

commemorated by the extensive improvements the Earl undertook in the grounds, notably the Golden Gates and the giant classical urn of 1847 set on the eastern axis of the house.

At Castle Fraser, Colonel Charles Mackenzie Fraser similarly employed the elder Smith on minor alterations and additions, now mostly eradicated. The Frasers fortunately had too much respect for their 'dear old château' to implement the proposals of the London architect William Wilkins (1778–1839) who had broken into the Scottish market with his Norfolk Tudor Dalmeny in 1814. His scheme of 1819 would have cut the house down to the corbelling, and ashlar faced what was left as a correct English Tudor castle with crenellated parapets, a treatment the Smiths actually applied to nearby Cluny in 1836–40.

However mistaken such a proposal may appear now, Wilkins was nonetheless a distinguished antiquary and a progressive house planner whose ideas were to have a profound influence upon William Burn (1789–1870), soon to become the premier country house architect of the century. Burn had been a pupil of Sir Robert Smirke whose symmetrical 'cubic geometry' he reproduced in neo-Tudor form at Saltoun, East Lothian in 1818–26, but from 1820 onwards he switched to Wilkins's Norfolk Tudor idiom; and in 1821, probably influenced by Wilkins's Dunmore Park, (nearby the Trust's Pineapple and now sadly in ruins) he developed his classic plan-type in which the private and principal apartments formed a continuous right-angled enfilade from family bed room to dining room. At that date, however, Burn's attitude to old houses still left something to be desired. In his work at Riccarton (1823) in Midlothian, now destroyed, he ashlar-faced the old tower house on the Wilkins model as the dominant element of a large asymmetrical English Elizabethan house with curvilinear gables and mullioned windows. His original proposals of 1824 for the Trust's Brodie Castle were on much the same principle, with extensive additions on both sides. William Brodie's inability to pay first for an ashlar face and then for the western section of the composition, allowing the old castle to retain its identity, brought second thoughts which represented an important turning point in Burn's career, since the same more respectful approach, encouraged no doubt by his friend Sir Walter Scott, was adopted at Lauriston Castle in the following year. Internally the principle of the right-angled enfilade was successfully applied by extending the principal suite in the old house by one large room to the south and then turning the new addition northward into an unusually generously planned private wing with the full suite of family bedroom, twin dressing rooms, bathroom and private sitting room. (Plate 27) In truncated form the principal suite did not have

the usual clear drawing room-library-dining room progression: James Wylson (1811–70) an architect with a chequered career who thereafter became Sir Charles Barry's principal assistant, reversed them to the correct arrangement in 1846 by refitting the dining room as the drawing room with a fine scheme of stencilled decoration, hopefully soon to be restored. Below, at ground floor level, he formed the library, an interesting classical design with columnar bookstacks, and remodelled the entrance hall as a low neo-Norman crypt. (Plate 28) Externally Wylson brought Burn's building more into conformity with the old house by crowstepping its gables as Burn himself would have done had he received the commission a little later.

Burn's interior work at Brodie had been Jacobean only at the present drawing room and even that has, and perhaps always had, a Louis chimneypiece. From the hybrid half-Scots half-English houses of the 1820s Burn and his principal assistant David Bryce (1803–76) gradually worked towards a fuller Scots Jacobean or Scots baronial treatment, in which great mullioned bays, justified in Scotland only by Pinkie House and the Earl's Palace at Kirkwall, remained a continuing feature. Except perhaps when adding to older houses there was no intention to deceive: Maybole Castle and the centrepiece of Fyvie might be freely copied, but only as part of complex new compositions which patently expressed sophisticated modern plan types, almost invariably executed in neatly squared stonework rather than traditional harled boulder rubble. By the 1830s they had come near to eclipsing Gillespie Graham altogether, but at Brodick Castle, reconstructed in 1844 for the Marquess of Douglas and Clydesdale and his wife Princess Marie of Baden, the ageing Gillespie had his chance to prove himself their equal. (Plate 29) He extended its main tower boldly westward as a continuous range to incorporate a correctly arranged enfilade of dining room, library, drawing room, boudoir and family bedroom, returning north-westward into the dressing room and other secondary apartments around the main stair, the principal spaces being lavishly decorated in a rich neo-Jacobean taste varied, as in Burn's houses, with an occasional Louis chimneypiece. (Plate 30) Externally Gillespie followed the sound if simple principle of basing the new on the old without recourse to Burn's bay windows to such good effect that it takes a moment or two to realise that the original castle was relatively small. Departing again from Burn's practice, he made the dominant element of the composition a completely new tower of tall and striking profile with a concave base and bartizaned angles which may, as with other Gillespie designs at this time, owe something to a sketch from his friend Pugin.

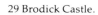
29 Brodick Castle.

30 The Drawing Room,
Brodick Castle.

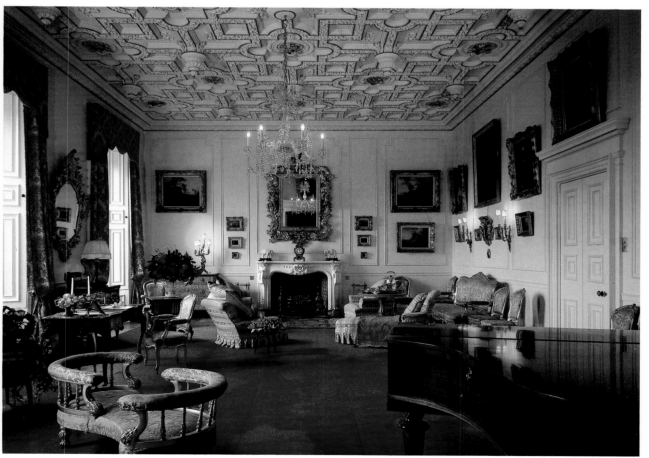

Pictorially and decoratively Brodick was an outstanding success but in planning it Gillespie had erred in one respect: he made the corridor along the rear of the principal apartments too narrow, a defect Burn proposed to correct in 1856, when he designed the rustic 'kiosque' in the gardens. In the ever increasingly large and confident castles and châteaux Bryce built in his maturity after Burn's departure for London in 1844, the hall corridor, now sometimes containing the billiard table, became an increasingly important element in the living space, just as it did in contemporary English houses. The Trust as yet possesses only one late example of Bryce's work, largely executed by his nephew and successor John (?–1922), in the remodelling of Drum Castle for Alexander Forbes Irvine. This house was very thoughtfully replanned to leave the original main elevations untouched. In 1876 the back court on the north was reconstructed as a low enclosed forecourt with a gatehouse, and in 1878–80 a new frontage containing a new entrance hall, main stair and hall corridor was veneered along what had been a featureless back elevation, inventively composed with a rope-moulded doorpiece in the rounded angle of the stair, but kept quiet with well-matched rubble work to avoid any conflict with the simple treatment of the original. Internally the shifting tastes of the late 1870s found expression in the timber ceilings which were then becoming fashionable even although the compartmented design had been a stock Bryce pattern since the 1840s.

In Threave House (1871) designed by his pupil C G H Kinnear (1830–94) and now occupied by the Trust's School of Practical Gardening, can be seen something of the vigour David Bryce applied to houses built anew although it was not a particularly expensive house, internally relatively simply finished. (Plate 31) Externally, however, its neat, compact plan was quite elaborately composed with a Castle Fraser type entrance tower (as at Bryce's Birkhill of 1855), and characteristic Bryce detailing at the turrets, bay windows and gables. Only a marginally less adroit handling of the proportions and of some of the secondary detailing betrays the pupil, as is also sometimes the case with James Maitland Wardrop (1824–82) whose country house practice came close to challenging comparison with Bryce's in both the Scots Baronial and the French château manners. In his work at Culzean where the then Marquess of Ailsa decided to have a private family wing like everyone else, tact was both required and supplied in 1875–78, Robert Adam's style being followed in a lower key with just some mullioned windows, a mullioned bay and a corbelled turret to indicate the real date. Designs for delightful Swiss cottages which would admirably have complemented the exotic character of the grounds were

provided in 1879–80 but regrettably not built. At Haddo Wardrop's addition of a plain family wing (removed 1930) was only one minor element of an otherwise very complicated and sumptuous package of work. In 1876 the 7th Earl (later 1st Marquess) commissioned a minor masterpiece of the Gothic Revival in the chapel, ante chapel and stair added to the north wing to designs by the London architect George Edmund Street (1824–81), then already building the chapel and library at Dunecht in the same county, an east window being commissioned from Morris and Burne-Jones: in the following year he married Ishbel Coutts Marjoribanks, and in 1879 Wardrop was instructed to bring the planning of the house up to date for her father's London decorators Wright and Mansfield. He brought the entrance down to ground floor level by providing the new porch and colonnades on the west front, a new entrance hall, and a new grand stair to first floor level, all tactfully and fastidiously designed but quite outshone by Wright and Mansfield's luxurious and precociously early Adam revival decor and furnishing

31 Threave House.

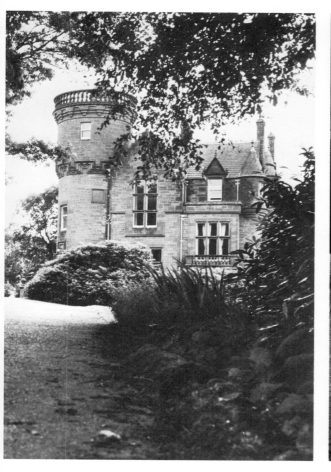

32 The Library, Haddo House.

47

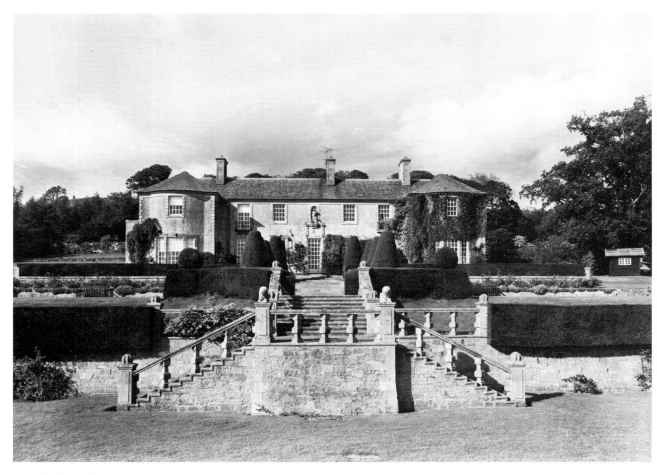

33 Hill of Tarvit from the
south.

which, now that their work for Ishbel's father at Brook
House, London, and Guisachan, Glen Affric, has gone, is
probably without parallel on either side of the border.
(Plate 32)

In Hill of Tarvit (1905) the Trust has a major example of the
work of the last great Scottish master of baronial country
house design, Sir Robert Lorimer (1864–1929) who inherited
the Scots baronial tradition from his apprenticeship with
Wardrop's son. (Plate 33) Close contact with the Arts and
Crafts movement in London brought a warm appreciation of
the materials and surface qualities of old houses, even if
only Formakin in Renfrewshire was actually built – wholly
successfully – to deceive. Hill of Tarvit lies slightly outwith
the mainstream of Lorimer's work, mainly because of the
tastes of the client who had formed a fine collection of
furniture, mainly French, which found its expression not
only in the interior decor but in a preliminary design for a
miniature château, something between early *dix-sèptieme*
and our own Caroline Park. In the event Sharp and Lorimer

48

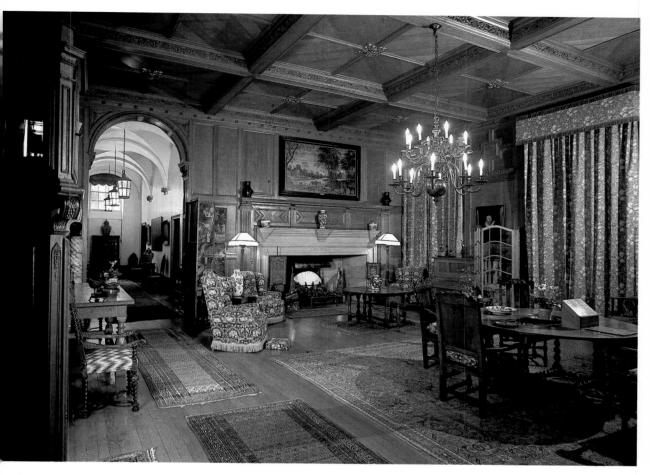

4 The Hall, Hill of Tarvit.

adopted the late seventeenth century Scots Renaissance of the smaller house which had stood on the site, producing a symmetrical-fronted white harled house with quoined angles, channel jointed surrounds, and Georgian-style bows presiding over a terraced formal garden. Within the hall had become the principal apartment, no longer a corridor at the back of the house but a fine square room in the centre of the main front. (Plate 34) Not only in elevation but in plan had the wheel of architectural fashion turned full circle.

DAVID WALKER

Further Reading

John Dunbar, *The Historic Architecture of Scotland* (1966)
Mark Girouard, *The Victorian Country House* (1971)
Jane Fawcett (ed.) *Seven Victorian Architects* (1976)
James Macaulay, *The Gothic Revival, 1745–1845* (1975)
Valerie Fiddes and Alistair Rowan, *Catalogue, Mr David Bryce* (1977)
Peter Savage, *Lorimer and the Edinburgh Craft Designers* (1980)

Keeping and Restoring

*I*n restoring the interiors of any of the historic buildings in the care of the National Trust for Scotland, the key is surely a simple one – every house has a character of its own and it must be allowed to speak for itself. Any restoration should be tempered with the utmost tact, integrity and, I would venture, humility. Personal taste should be underplayed as far as possible and even that windmill – historical accuracy – needs the odd tilt. It is one thing to redecorate one's own home, but quite another to deal with historic buildings of the varying degrees of importance that are held in Trust for the benefit of the nation and future generations. It does not however mean that there is no room for flair, and imagination – there is – for without them the interiors might tend to be rather too dry and academic. The houses in the Trust's care divide themselves fairly easily into three groups.

The first includes those that contain a varied collection of furniture, pictures, porcelain and works of art, that have been gathered together over the years by generations of the same family. Clearly there was no attempt to relate the collections to the buildings and the idea of period accuracy was never considered until well into the present century, if at all. Houses in this group are either still being lived in, or have been until fairly recently. They include the The Binns, Craigievar, Brodick, Brodie, Kellie, Haddo and Drum.

A second group embraces houses such as Crathes and Castle Fraser which have not been lived in for a considerable number of years. In each case the collections are depleted because not all the furnishings were given to the Trust when the building was made over. In addition Crathes suffered on account of the disastrous fire of 1966 when both the Queen Anne and Victorian wings were gutted. Fortunately, the early vernacular furniture was in the old part of the Castle, and escaped the ravages of the fire, nevertheless there was a considerable vacuum and the collections had to be substantially and subtly augmented so that any additions fitted in harmoniously and appeared to have always been there; Leith Hall should perhaps also be included here although only a quarter of the house is shown.

In the third group are Culzean, the Georgian House, Gladstone's Land, and the cottage properties such as the Bachelors's Club, and Hugh Miller's cottage in Cromarty, and Hill of Tarvit. This last is essentially an Edwardian house designed by Lorimer to accommodate a connoisseur's collection of furniture, pictures, porcelain, tapestries and bronzes, in appropriate settings with a decidedly period *mise en scène*.

With the Georgian House and Gladstone's Land a serious attempt has been made to recreate interiors of a specific period. At Culzean, a complete period rehabilitation was not possible because, in the first place, the building had undergone considerable alterations towards the end of the 19th century, a new family wing had been built and some of the Robert Adam rooms had been destroyed to accommodate a changed way of life. In the second place, a great deal of the original furniture had been removed and, in addition, what was considered to be essential contents in 1945 was only a small proportion of what would be considered essential today.

For those houses in the first group one is guided by several very different factors. The first is the quality of the contents which tend to dictate to some extent how a room should be rehabilitated. The second is the way in which previous generations and indeed the present family, if there is one, lived in the house, what wallpapers and what materials tended to be used. The third is the study of the archives which can generally be most revealing. These three factors tend to fuse together quite happily.

To take Brodie as a typical example, months were spent going through the family papers to see how the collections had been built up, and how the rooms had been used. The collections themselves are of very high quality and there is a predominance of paintings, ranging from the 17th century to the present day, mostly acquired by the grandparents of Ninian Brodie, who is still collecting. By tradition striped wallpapers tended to be used together with delightful old chintzes. This family tradition has been followed by the Trust, so that the house has retained its essential character and is quite unlike any other Trust property. Because virtually nothing had ever been thrown away, it has also been possible to restore the 19th century kitchen and show it much as it appeared until 1939. (Plate 35) All the coppers and a great deal of ordinary everyday equipment had fortunately survived. During the last war a large coal range and hot plate had been removed to make way for linen cupboards and these have now been replaced with very similar models. A charming octagonal dairy still remains to be carefully restored at some future date.

35 The Kitchen, The Georgian
House.

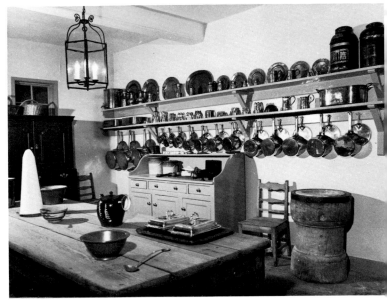

36 Carpets copied from
originals at Haddo House.

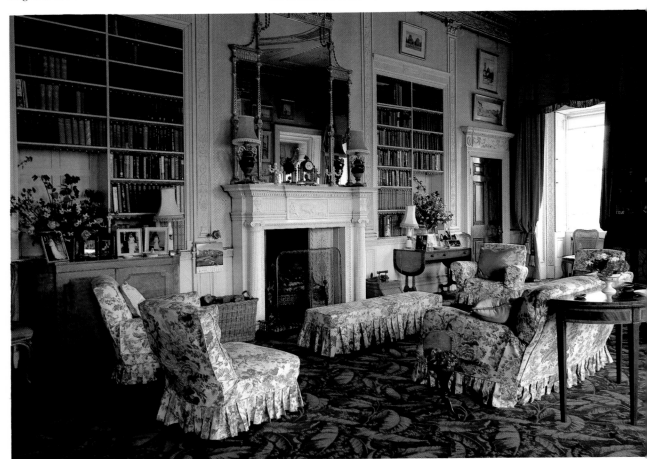

At Haddo, the Adam Revival interiors have been respected for what they are and the colour schemes are being restored to those of 1880. Many of the threadbare Brussels loop carpets have been faithfully copied, although some of the colours might appear somewhat loud by today's standards. A subtle compromise was effected in the Dining Room. The old carpet which was due for replacement had originally been a strong blue but had faded to a delicate shade of green. It was the green that was copied and historical accuracy was sacrificed in favour of what the family had known and liked for over 50 years. (Plate 36)

The Binns presented an interior which had been altered considerably over the centuries and each period had left its mark; thus the seventeenth century panelled rooms, those with important plaster ceilings together with the eighteenth century dining room and morning room all jostle happily together under the somewhat dour external mask applied by William Burn in the nineteenth century. The obvious key to the interpretation of such a house was to show off the splendid variety of furniture, porcelain and family portraits in the best possible way and in as sympathetic a setting as possible. Most of the colour schemes were based on existing fabrics in the house. It was, and still is, essentially a lived in house with a good general collection where a strong family tradition survives.

Kellie is still very much a home, and each time another room is tackled the family tradition is always remembered. Recently the dining room was relined with linen as before, and at the same time a hob grate was installed replacing an unsightly storage heater. (Plate 37)

The second group can to some extent be treated with more historical accuracy than the first. Family tradition tends to fade quite quickly if it has not been kept alive and cherished. If it has not survived, one is free to concentrate on historical accuracy which after all is always there. When Crathes was given to the Trust in the 1950s it was still a family home, and it contained the usual country house collection of furniture: a good run of family portraits, and decorative items, at the core of which was the vernacular furniture. Fortunately this was in the old part of the Castle at the time of the fire, and it is these objects together with the important painted ceilings that inspired the new interpretation of the interior. The diminished collections have been carefully added to with the accent on early vernacular items, rather than on a general country house collection. Perhaps this is a good place to mention the sterling work of the Stenhouse Conservation Centre which was specially set up by the Trust to handle the correct treatment of painted ceilings throughout Scotland.

So many archaeological investigations had been made at

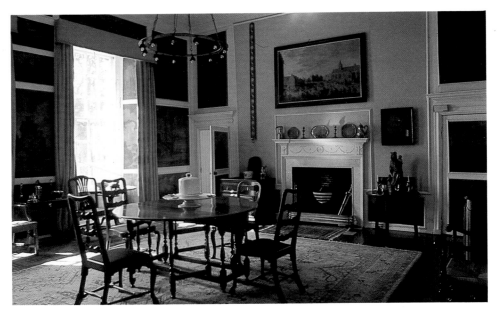

37 The Dining Room, Kellie Castle.

Castle Fraser since the 1920s when it was purchased from the Frasers by the Hon. Clive Pearson, that little remained of any specific period by the time it was given to the Trust in 1978. The High Hall had been partially restored to its 17th century form but all archaeological evidence had been carefully left exposed. Most of the original furniture had been removed leaving only a comparatively small amount that was given to the Trust including some good early oak pieces, and a delightful suite of painted furniture in the Worked Room. Some of the rooms were quite bare, but even before the Trust opened the property to the public a great many of the gaps had been filled with appropriate pieces in character with the Castle. The bedrooms tend to reflect late 18th and early 19th century taste, and this tradition has been respected: similar materials have replaced those beyond repair and at least one Castle Fraser carpet has been copied.

The third group embraces the three properties where perhaps the Trust is seen to be purist and possibly by some too much so. The historical restoration of early colour schemes and the special weaving of fabrics has an important place in such work.

Culzean was the first property to undergo the systematic programme of research into original late 18th century colour schemes. Since 1945 various attempts had been made on a limited budget to interpret the Robert Adam interiors but it was not until 1972 that it was possible to begin a thorough investigation by taking scrapes and cross sections of paintwork and implement a full restoration programme. (Plate 38) The property also presented other problems. It would have

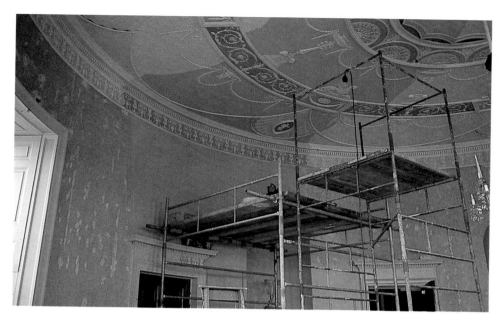

38 The Saloon, Culzean Castle, during restoration.

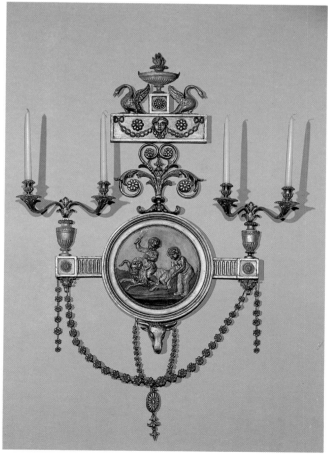

39 Girandole from Culzean Castle.

been unthinkable to restore the whole house to its 18th century original and compromises had to be made. Structural changes made in the last century had to remain but fortunately they were confined to the ground floor.

Whilst it was possible and desirable to show the first floor – the piano nobile – in a formal 18th century manner, it was considered equally acceptable to show changes that had occurred downstairs with the Adam Revival dining room, formerly the Library and a dressing room, the Armoury set up in the last century and accommodated in what had been the entrance hall and buffet room, and lastly, the Old Eating Room of Adam's day furnished now as a family sitting room. It had become a Library in Victorian days and the proportions were greatly marred by the addition of truly hideous dwarf bookcases. Thus the story of the development of Culzean is told, starting with 18th century formality, through the changes in the way of life in the 19th century, to the more relaxed atmosphere of today. Even this delicately balanced compromise could not be implemented with complete success on account of the lack of original furniture.

At least one room has been rehabilitated each year since 1972 and before work is completed investigations are carried out concurrently on another room thus enabling materials to be selected and ordered in plenty of time and also showing visitors what is happening. The Robert Adam girandoles and looking glasses which over the years had become defective have all been fully restored to their original condition. (Plate 39)

In a peculiar way the setting up and furnishing of the Georgian House followed on very naturally from Culzean. It was decided at the beginning to restore the original colour schemes throughout the house with the exception of the bedchamber because the four-post bed retaining its 18th century moreen hangings dictated the colour of the walls. Furthermore so little of the original colour scheme remained in the drawing room that a particularly successfully restored 1795 scheme at Culzean was used. Before rehabilitation No. 7 Charlotte Square appeared dull and unprepossessing, but even here it was possible to allow the simple integrity of the house to speak for itself. It was not and never has been a Stately Home, just a straightforward professional man's house. Apart from the splendid marble chimney piece in the drawing room which replaced one that was vandalised, Victorian chimney pieces in other rooms were removed in favour of simple late 18th century wooden examples. (Plate 40)

The bequest of the drawing room seat furniture was obviously intended for a room of parade and was the key to the furnishing of the house. All the furniture was gathered

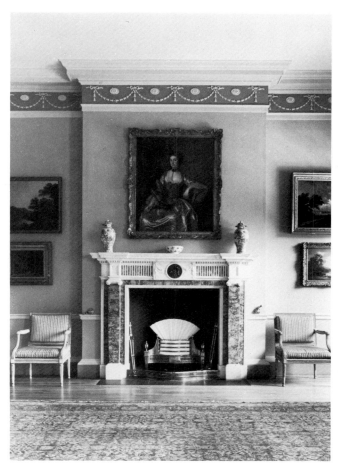

40 The Drawing Room
chimney piece, The Georgian
House.

41 Gladstone's Land, during
restoration.

together by way of gift, bequest, and purchase. One continues to improve, and weed out, so that there are always changes in the display. It was at the Georgian House that the first positive attempt was made to show a period kitchen and although the idea was frowned on at the beginning, it has proved enormously popular, perhaps because visitors can relate more readily to the familiar homely objects on show than to the formal reception rooms.

Gladstone's Land, another essentially middle class period interior was opened in 1980. It attempts to do for the old town, what the Georgian House does for the New, and also includes a reconstructed 17th century shop. The painted ceiling and friezes of 1620 were carefully restored. (Plate 41) Owing to the scarcity of early 17th century furniture, it was decided to show the house as it might have appeared towards the end of the century, and so began a quest for suitable oak furniture – Scottish, if possible, together with brass, pewter, treen, and crude earthenware. It has been a fascinating task and, as with the Georgian House, one continues to keep one's eyes open for more suitable material.

The last property to be mentioned in this group is Hill of Tarvit in Fife. Although remodelled by Lorimer in the early years of this century to take a specialised collection of furniture, pictures and objets d'art, it is nevertheless an Edwardian country house. For many years after it came to the Trust it had been a Nursing Home, with the result that the elusive family spirit had quite gone. In recent years it has been taken back under the Trust's umbrella and the collections have been restored. Once again care has been taken to use wallpapers as near as possible to those used originally together with the chintzes so popular at that time. It is planned one day to open the servants' quarters. It represents in a modest way, the final flowering of the smaller house and retains to some extent a faintly blowzy Edwardian atmosphere.

DAVID LEARMONT

Further Reading

John Cornforth, *English Interiors, 1790–1840* (1978)
John Cornforth and John Fowler, *English Decoration in the 18 Century* (1974)
Peter Thornton, *Seventeenth Century Decoration in England, France and Holland* (1978)
Geoffrey Beard, *Decorative Plasterwork in Great Britain* (1975)

Fabric Furnishings

Of all furnishings from the past, textiles are the most vulnerable, most subject to destruction. Glass and ceramics are handled with care, paintings hang on walls out of harm's way, silver is cherished for its value: compared with these, soft furnishings are subjected to immensely hard wear. Curtains are drawn to and fro, counterpanes folded and unfolded, carpets take the weight and friction of leather soles, while chair covers have to bear the weight and friction of the human body. Grime and light, those two enemies of textiles, take their toll virtually unchecked. In comparison, destruction by moth is minimal, especially in Scotland, where the climate discourages the clothes moth (*tineola bisselliella*), which prefers warmer temperatures, from breeding. There are, it is true, others, notably the tapestry moth (*trichophaga tapetzella*), that will breed in a colder climate, especially in damp conditions, but sheer wear and tear, rather than insect pests, caused most of the textiles of the past to perish.

Curtains, coverings, cushions and carpets are regarded as expendable. The most rapid and effective way of refurbishing a room has always been to renew the wall coverings and to replace faded or worn curtains, chair covers and carpets. The wealthy could order new furniture as well, but even in the thriftiest household, new curtains could be made at home, and fresh chair covers contrived to replace shabby or torn seats.

It is therefore surprising to find any soft furnishings that have lasted for fifty years : it is even more remarkable that there should be so many in Scotland that have survived for two, three or even four centuries, often still in the house for which they were first made. The evidence of these textiles, together with contemporary inventories of large and small houses, offer essential guidance to those who have to restore historic houses to their original appearance. They are a necessary corrective to interior decorators' ideas of 'period' furnishings.

The most important article of domestic furniture was undoubtedly the bed, usually listed first in an inventory. In a large house, a four-posted bed ('four neukit' in Scotland)

was a necessity; its curtains when drawn protected from icy draughts, and offered some privacy when, as was customary, one room opened out of another. It was the stage upon which the drama of birth and death was enacted: in it the newly delivered mother received the congratulations of neighbours and friends; around it the mourners gathered at death. Like a stage, it had curtains and a backcloth, with valances, or *pands* in Scottish inventories (Fr. *pentes*), around the canopy or tester.

The citizens of Edinburgh might hang their beds with warm striped 'Musselburgh stuff', but in larger houses the bed, a much more public piece of furniture than is now the case, was hung with richer materials to display wealth and colour. A surprising number of splendid sixteenth century valances have survived in Scotland, many from Perthshire castles. One set, now in the Burrell collection, came from Balloch (now Taymouth Castle), and bear the arms and initials of Sir Colin Campbell of Glenorchy and his second wife, Katharine Ruthven. They married in 1550, and he died in 1585. They show spirited embroidered scenes of the *Temptation* and the *Expulsion from Paradise*: edifying decoration for the bed of a couple who had four sons and four daughters.

Other Scottish valances of this type, worked on canvas in wool and silk, show detailed scriptural or mythological scenes, the characters wearing the elaborate costumes of the court of Henri III of France. Inevitably, many of these finely worked valances have been attributed to the needle of Mary Queen of Scots because of the costume, though the drawing and the technique point to a professional workshop. One, belonging to the Duke of Buccleuch, shows Daniel being rescued from the lions' den. The design derives from two engravings by H. Cock published 1565, after Martin Heemskerck, but the needlework shows King Darius arrayed in rich robes and a ruff; the ladies and gentlemen of his court crowd around the pit in fashionable French outfits.

No curtains have survived with these rich and durable valances, but the Campbell set were still in use in 1640, hung on a bed with curtains of green and yellow changeable taffeta, and a counterpane of blue and yellow silk. In the same year, the Earl of Nithsdale, gone to fight for his King, left at Caerlavrock Castle in Dumfriesshire 'a great wrought [embroidered] bed, a sute of cloth of silver chairs and stools to be made up, and an embroidered Canaby of Gray Sattin to be made up, too.'

The handsome red damask bed, still at Blair Castle, serves to remind us of the difficulties and expense entailed in the effort to furnish a room to accord with the importance of its owners. The bed was ordered from London in 1700 by the Countess of Tullibardine, while the Earl still enjoyed a Crown

appointment that entitled him to an apartment at Holyrood. She first proposed sending taken-down damask curtains to London to be dyed for the hangings. Her sister-in-law, the Countess of Orkney, dissuaded her from this thrifty idea: – 'Ye rich damask died a dark sky-blew is the best you can die them, but I must tell you yt rich damask dies worse than a worse damask; I have try'd itt upon the same occasion. I tell you this because you may not be surprised at their looking died, which they will. I believe ye number of yards may make a bed, but not a cover to one, bot you may have an Indian quilt, which will look very well.' Lady Orkney's advice was accepted, and the rich new crimson damask selected still retains its opulent sheen.

The bed was sent by sea to Edinburgh in 1700. Lady Orkney wrote: 'Ye expense of making it up was more than was possible for me to forsee . . . and since you were making of a bed, which is not don often, it was best to make it as high as was fit for ye room you design itt for . . . Ye counterpane [embroidered with the Murray cipher] I hope you will lick. I had it worked a purpose, and I desire you will except it from me as a small mark of my respect . . .'

The Holyrood apartment had to be vacated at the end of office, and the bed stored. In 1703 Lord Tullibardine became the first Duke of Atholl. In 1707 his wife died. Relatives and friends tried unsucessfully to dispose of the bed for him, together with the chairs and hangings, pointing out that it was cheaper than buying new from London, but to no avail. In 1709 it made the perilous journey across the Forth to Burntisland, and thence to Blair Castle. 'The largest Hay Wain' was ordered to transport the roof of the bed, with 'good men, not boyes, to wait on the carts.' No account has been located for this bed, but the Duke's father-in-law, the Duke of Hamilton, had paid £326 sterling twelve years previously for an embroidered bed, chairs and couch in London.

The domestic needlewoman could, and did, employ her needle to decorate bed hangings and other furnishings. As well as valances, a great many bed curtains have survived. Some have been mounted on to other beds while others serve as bedcovers or window curtains. (Plate 42) The National Trust for Scotland is fortunate in having two beds, complete with their needlework hangings, on display: the enchanting painted bed at the Georgian House, Edinburgh, on loan from Newliston, and the equally charming mahogany bed in the Worked Room at Castle Fraser. The hangings on both beds are of *moreen*, a watered woollen repp much used for upholstery in the eighteenth and early nineteenth century. Both sets were made with matching window curtains: in addition, the room at Castle Fraser has pelmets as well as a

42 Detail from a late seventeenth century crewel-work hanging, Falkland Palace.

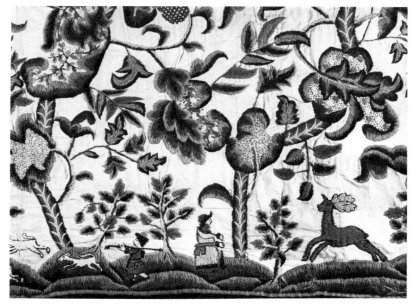

43 Part of a suite of seat furniture from Castle Fraser.

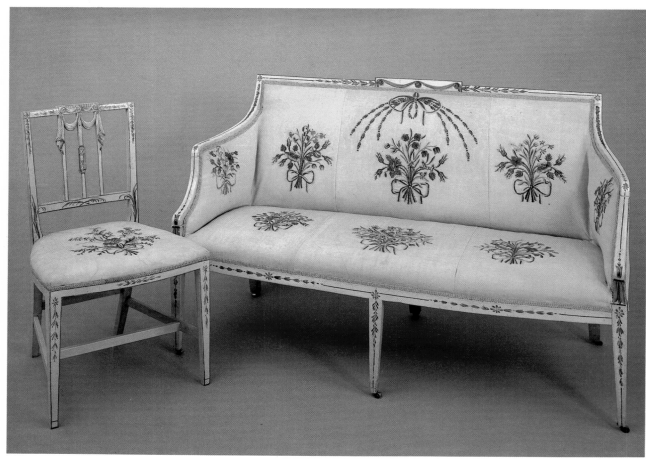

sofa and four chairs, all embellished with graceful nosegays of well-drawn flowers worked in crewels. (Plate 43) There is a tradition, though it lacks documentary evidence, that the set was worked by Miss Elyza Fraser (1734–1814) and her friend, Mary Bristow (died 1805). It is a happy accident that this seat furniture should have lasted in such good condition; most chair covers of this period, except those of canvas work, have disintegrated and been replaced.

Canvas work covers, on the other hand, have survived in large numbers: not because canvas work was the most common covering for upholstery in the past, but because it is hard-wearing, and because large sets of chairs, particularly in public rooms, had slip-covers to protect them from dust and light. To this must be added filial piety, that regarded the needlework of an ancestress with respect, and treated it with care.

Six chairs from such a set have been given to Culzean Castle. They are believed to have been worked by the mother of the first Duke of Wellington. She was Anne, Lady Mornington (1742–1831). The chair on display shows rustic card players, others show mythological scenes, such as *Narcissus* and the *Forge of Vulcan*. (Plate 44)

A handsome armchair from Drum Castle is covered with cross-stitch taken from a damask pattern. (Plate 45) Also from Drum Castle, a side chair from a set of six, is covered with canvas work in a basket-work design, in shades of yellow and green. (Plate 46) This geometrical canvas work was popular in Scotland; it requires no skill in drawing, merely counting out, like a knitting pattern, and is usually worked in graduated shades of cross or rice stitch. Other examples may be seen at Mellerstain and Blair Castle. This type of pattern also occurs unexpectedly on chair covers of the same period in Pennsylvania.

Needlework pictures for a wall or a fire screen added colour and warmth to the domestic interior, and offered a fine opportunity to the needlewoman to display her skill. (Plate 47) Large woven tapestries, the 'arras hingings' of the old inventories, went out of fashion in the eighteenth century, though they kept their place in older houses. Instead, paint or wallpaper became the fashion. In 1774 Thomas Chippendale supplied Ninian Home at Paxton, Berwickshire, with wallpaper printed to match the chintz bedhangings and chair covers. Three years later the Edinburgh firm of William Hamilton furnished a bedroom at Hamilton Palace with chintz hangings for a bedstead 'in the Gothick manner' and window curtains, chair covers and wallpaper 'same Pattern as the Chintz'. Even the Comte d'Artois, the future Charles X of France, when the State apartments at Holyrood were fitted out for his occupation in

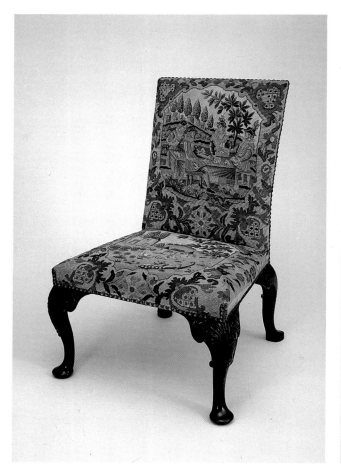

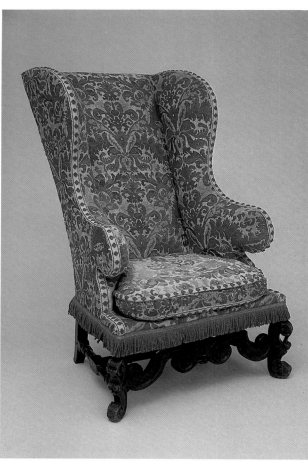

44 One of twelve carved
mahogany chairs worked
with scenes of rustic card
players, Culzean Castle.

45 Wing-back chair worked in
cross-stitch, Drum Castle.

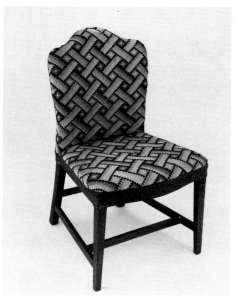

46 Side chair worked in a
basket-work pattern, Drum
Castle.

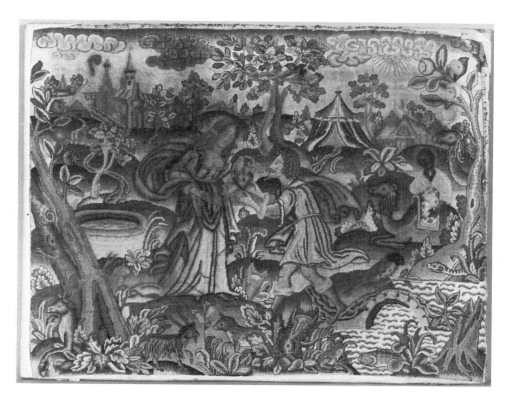

47 Mid-seventeenth century needle-work picture of Rebecca and Elizier, Kellie Castle.

1796, had a large mahogany bed hung with 'Chintz callicoe' in the most up to date manner with pelmets, window curtains and slip covers on the chairs to match: a radical change from the silken splendour of the French court of his brother, Louis XVI. The pattern of the chintz is not noted; the wallpaper provided had a green ground with a rich border. There was, moreover, a carpet: 79½ yards of new carpet with a chocolate ground. Other public rooms were also fitted with carpets.

He was, of course, the heir-apparent to the French throne, and the cost was being borne by the British government. Private owners were not quite so lavish in providing carpets in bedrooms. In Hamilton Palace in 1777, the Duchess's bedroom and dressing room had a carpet in shades of blue to accord with the bed hangings of blue striped silk, but the other bedrooms merely had a carpet round the bed, or sometimes 'in front of the bed'. Despite the ample bed drapery, the bare floors would appear spartan to modern eyes. At Holyrood, the Comte d'Artois had a carpet in his dining room, with 'India matting' in front of the sideboard. The gentlemen on his staff had no carpet in the Lower Dining Room, where they took their meals, though provided with good mahogany furniture. At Hamilton Palace, the High Great Dining Room received a Scotch Carpet: reversible double-warp carpet without a pile, woven in Scotland from

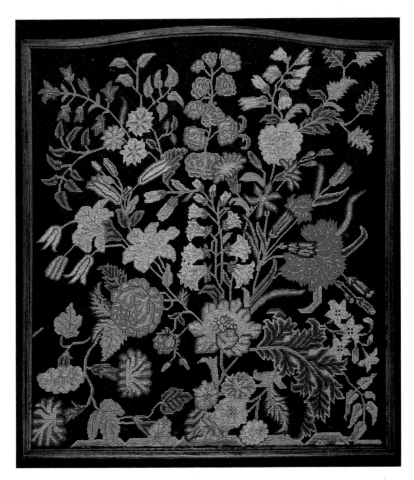

48 Mid-eighteenth century pole screen with needle-work panel, The Georgian House.

the middle of the eighteenth century till the 1930's. They were cheaper, but not so hard-wearing as a carpet with a pile. There is one on the floor of the Worked Room at Castle Fraser, and another at Crathes. The two most striking carpets in the collection of the National Trust of Scotland must surely be the circular carpet at Culzean, of Robert Adam's design, and the carpet at Brodie Castle shown in the Great Exhibition of 1851.

These, together with the bedhangings, chair covers and other textile furnishings preserved in historic houses, provide immediate and sometimes touching evidence of the taste and attitudes of their owners.

MARGARET SWAIN

Further Reading

Christopher Gilbert, *The Life and Work of Thomas Chippendale* (1978)
Marjorie Plant, *The Domestic Life of Scotland in the eighteenth century* (1952)
Margaret Swain, *Historical Needlework* (1970)
Margaret Swain, *The Needlework of Mary Queen of Scots* (1973)
Peter Thornton, *Interior Decoration in England, France and Holland* (1978)

Silver in Trust

When the National Trust – either in Scotland or England – accepts a property its owners have all too often been trying to make ends meet for many years past. One of the ways this has been done is by selling off either one spectacular object or a group whose absence may not be too noticeable. Silver and books are the obvious candidates for this. Thus it often happens that the Trust receives a house and contents singularly denuded of silver or small objects of art. Oddly enough, this is no bad thing. Books are almost impossible to display and subject to damage from the light if left open for long periods. Fine porcelain worth enormous sums if perfect, can be reduced in value by 75% by the smallest crack or chip occasioned during even routine dusting. Silver, unfortunately, is thought by many to be of great value for the material alone. This is not in fact the case, but to say so will not change the habits of generations of thieves. So there is a considerable security problem which the Trust must face, not to mention reasonable insurance. What then has the National Trust for Scotland in its care by way of silver? The answer is one quite remarkable collection at Brodick which came to the Trust from the late Duchess of Montrose by way of an arrangement with the Treasury on her death and a number of other interesting pieces scattered here and there, from Brodie in the North to Culzean in the South-West.

At Brodie there appeared during the preliminary sorting out a red morroco cylindrical case which proved to contain the silver baton of the High Constable of Scotland carried on the occasion of the Royal Visit to Scotland by King George IV in 1822 – a visit almost wholly organised by Sir Walter Scott. (Plate 49) The then Earl of Errol, the hereditary High Constable, being a minor, the Marquess of Huntly deputised for him. Also at Brodie there are a couple of gold topped malacca walking canes, one by Andrew Hogg hall marked 1778 and engraved Lord William Gordon North Fenc(ibles). Lord William would have used this when in camp though not, of course, on parade. Small objects such as snuff and nutmeg boxes are very often retained by members of the original family and thus the pieces in the display tables at

Drum Castle and Leith Hall, whilst of considerable interest are not outstanding in terms of quality. At Drum however are two silver hilted swords. (Plate 50) One is a court sword of standard mid 18th century form as carried by every gentleman and probably very similar to that purchased in a rash moment by young James Boswell upon his first arriving in London. The other is a very nice hunting sword or hanger with finely cast and chased hilt by William Strange 1733.

This is perhaps the moment to draw attention to the comparative lack of Scottish made silver, even from Edinburgh or Glasgow, in Scottish houses as a whole. It would seem that the normal toll of wear and tear must have reduced the survival of anything made prior to 1760. And of course the cost of two risings in 1715 and 1745 added to this, when supporters raised money by the sale of plate beforehand and yet more when they compounded for their estates afterwards. A similar situation had obtained in England during the previous century. From 1760 the comparative mass production of Birmingham and Sheffield also began to be felt by Scottish silversmiths. This is not to say that a great deal of table silver – spoons and forks – was not produced in Edinburgh and Glasgow but 'wrought plate' in the way of tea and coffee services, cups and covers, sauceboats etc. of Scottish manufacture accounts for perhaps only one tenth of the silver remaining in Scottish houses. The vast majority of successful Scots made their money south of the border and usually beyond sea. Those in India bought their requirements as needed from flourishing Scottish firms such as Hamilton & Co. in Calcutta, those in England looked to London. Their return – when return they did – to their native shores saw them fully supplied and their needs were seldom more than the odd repair or perhaps a presentation piece. Only the merchants of Glasgow and the practitioners of the law in Edinburgh and a few of the smaller burghs could be expected to become stable clients to most silversmiths and it is in houses and families of these 'legal eagles' that most of the more interesting survivals are still found. Objects in gold are very rare in any case. The Trust cannot produce anything like the two gold tea-pots made as prizes for the King's plate at Leith by James Kerr of Edinburgh in 1736 and 1737, but it has received something almost as rare. These are a pair of solid gold spurs at Castle Fraser given to Colonel Mackenzie by the Officers of the 78th Regiment in 1801. Other than those of much earlier date amongst the Coronation regalia in the Tower of London, these are the only solid gold spurs – traditionally the mark of a Knight – known to survive. (Plate 51) Not perhaps everybody's taste are the pair of silver-gilt mounted ostrich egg ewers of 1866/7 from Haddo House. (Plate 52) Here one suspects the returning travellers

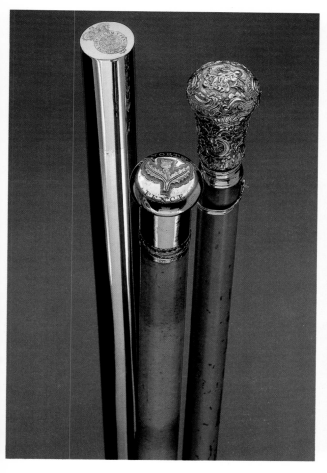

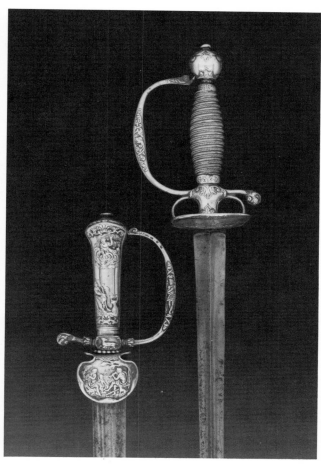

49 Silver baton of the High Constable of Scotland, 1822, and two gold topped malacca walking canes, Brodie Castle.

50 Hilts of court sword c. 1760 (right) and hunting sword, 1733 (left) Drum Castle.

wondering what on earth to do with his mementoes. They have close fitting silver linings to the interiors which poses the nice problem as to how they were inserted without damaging the eggs!

Amongst the silver at Haddo there is a most attractive oval ewer and basin. The latter made in Nuremberg by Heinrich Straub about 1650. The former bearing the maker's mark only of Jacob Bodendick, an anglicised Fleming who worked in London about 1670, the corpus of whose surviving work and appreciation of it is steadily growing. (Plates 53 and 54). It is possible that this ewer and basin formed part of a toilet service, but sadly, if it were so, no more has survived. On the other hand a few such oval basins have survived in Continental collections with animal or mounted figures instead of ewers. aesthetically a much more attractive combination and perhaps the original purpose of this basin. The collection at Hill of Tarvit in Fife contains a number of pieces of practical use such as a tea-pot by Paul Storr and there is rather a charming composite tea-service by Langlands

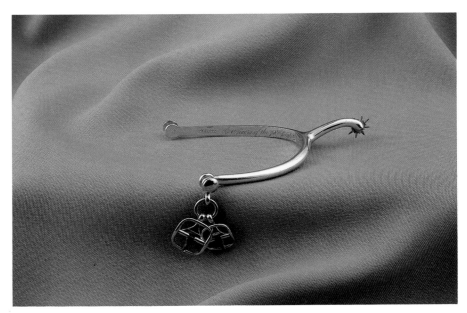

51 One of a pair of solid gold spurs, 1801, Castle Fraser.

52 Silver-gilt ostrich eggs ewers, 1866/67, Haddo House.

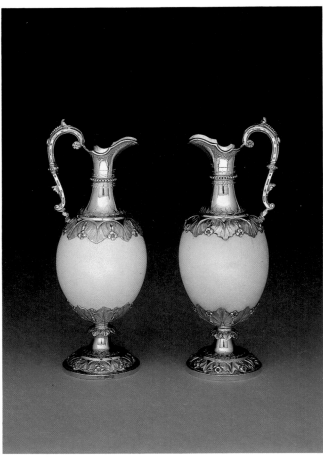

and Robertson, Newcastle 1813 with the sugar basin and cream jug made to match in Edinburgh, at The Georgian House in Charlotte Square together with some interesting pieces of early Sheffield plate. On the whole the Trust has no need or use for whole services of table silver, as it can rarely be displayed except upon the dining room table and enough for one course is quite sufficient. It is a little sad to think that in England a number of houses have been handed to the Trust in the past with vast services including ranges of candlesticks and dinner plates which are inalienable and yet almost impossible to display except by the mounting of some special exhibition. Even then twelve dozen identical dinner plates are not the most thrilling spectacle even to the most avid collector.

The Trust in Scotland has, however, one spectacular collection and that is the contents of the strong room at Brodick Castle on the Isle of Arran. This includes not only pieces from the collection of the great eccentric William Beckford, but also from the 10th Duke of Hamilton and very

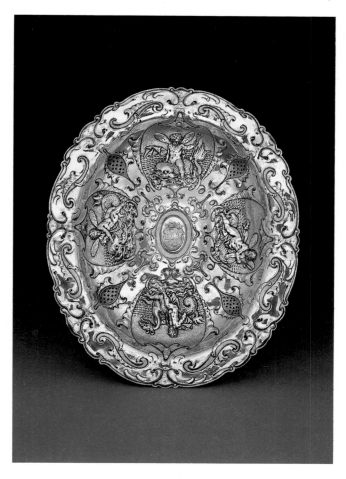

53 Mid-seventeenth century silver-gilt basin, Haddo House.

probably the Princess Marie of Baden. This collection was shown in London in 1980 and York in 1981 and a very scholarly catalogue was produced at that time. Not all of it can be on view in the castle at once, but a great part may be seen and it seems best to draw attention to a few of the most notable pieces rather than try to cover the whole breadth of the collection. There are several pairs and sets of wall sconces, the rarest being those by Paul Storr 1804 which are extremely attractive and also amongst the latest – and smallest – to survive. These and a considerable number of silver-gilt mounted Chinese porcelain objects are 'Beckfordiana' liberally decorated with the heraldic charges by which Beckford sought to prove his lineage so good as to enable the Duke of Hamilton to marry his daughter Susan Euphemia. Fortunately, the Duke was something of an antiquarian, also an eccentric like his father-in-law and above all, short of money. For once there is at Brodick something fairly early and Scottish, a pair of so-called thistle cups, each of about half a pint capacity and made by Robert Inglis in Edinburgh in 1692. (Plate 55) A very early earthenware pig flask with German silver mounts and a number of other mounted glass and porcelain pieces probably stem from the Baden connection as do the range of 17th and early 18th century tankards and beakers, some of the latter being outstanding. This is, however, by no means certain for the 10th Duke certainly collected a number of such pieces himself. Besides these, amongst the Continental silver are a group of silver mounted hardwood, some painted, standing figures of varying quality and a collection of engraved tobacco boxes. These are the predecessors of the snuff box which later ousted the tobacco box in most countries except Holland where it became the practice to sell snuff ready-ground rather than in plug tobacco form. Brass tobacco boxes for the artisan continued to be made until much later. As might be expected, there are the usual services of soup and sauce tureens, candlesticks and candelabra which were required in a great house though nothing to compare with those surviving at Althorpe in Northamptonshire which retains over two hundred silver candlesticks, some in sets of a dozen or more and all of which would have been used on great occasions. At Brodick there remains a set of four table candlesticks by John Schofield 1791 and four smaller examples of 1781 and 1817 all in the classical manner and part of a vast matching set – some being gilt – dispersed within the family, some only recently sold. (Plate 56) The sconces include Royal Plate acquired by Beckford in 1808 from the Royal Goldsmiths. The originals are by Andrew Moore 1688, the copies 1824 and 1842 although even the copies were engraved with the same Royal Crown and Monogram. Perhaps the most *outré* piece is a wicker

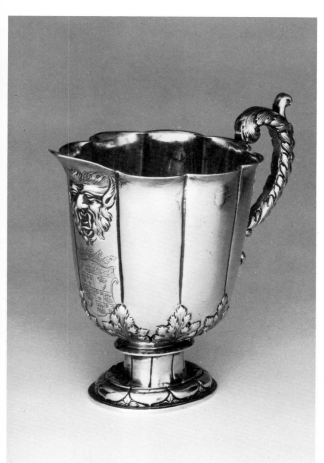

54 Late seventeenth century silver-gilt ewer, Haddo House.

55 Pair of thistle cups, Edinburgh 1692, Brodick Castle.

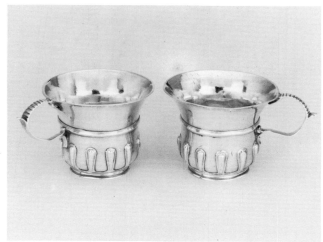

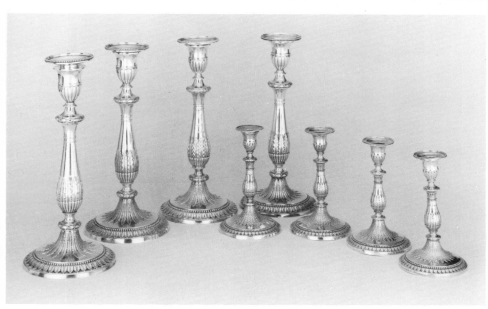

56 Group of candlesticks dating 1781, 1791 and 1817, Brodick Castle.

57 One of a pair of silver candlesticks, London 1841, Brodick Castle.

covered rehoboam, the stopper formed as the crest of Hamilton. The serpent candelabra at Brodick are perhaps more fascinating than attractive, but all in all the National Trust for Scotland has every cause to be very proud indeed of this remarkable house and its princely contents, not to mention the wonderful gardens in which it stands. (Plate 57)

MICHAEL CLAYTON

Further Reading

Michael Clayton, *Collector's Dictionary of Silver and Gold of Great Britain and North America* (1971)
Carl Hermarck, *The Art of European Silversmiths* (1977), 2 vols.
John Hayward and others, *Catalogue, Beckford and Hamilton Silver from Brodick Castle* (1980)
Charles Oman, *English Domestic Silver* (1949)

Porcelain in Trust

Certain of the National Trust's houses, notably The Binns, Hill of Tarvit, and the castles of Brodick, Brodie, Drum and Fraser, include fine collections of porcelain among their treasures. While the majority are of Chinese origin some of the pieces are European. (Plates 58 and 59) This is not surprising as a flourishing commerce had developed between China and Europe in porcelains whose shapes and designs were made for the export market. A specialised activity of these export wares was the production of table services decorated with the armorial devices of the customers framed in suitably becoming decoration – a style completely alien to the Chinese themselves who pragmatically adapted their techniques and skills to the market's needs. Such armorial dinner, tea and coffee services may still be found in England and Scotland in the homes of the families who had commissioned them.

Although a steady export trade had flourished with the lands of the Near East and South East Asia since the ninth century, Chinese porcelains only began to enter the European markets in significant numbers in the sixteenth century, through the enterprise of Portuguese traders. The most popular type was white porcelain decorated with designs painted in underglaze blue. By the seventeenth century the trade had passed into the hands of Dutch East India merchants who shipped large quantities of white porcelian whose designs of busily patterned flower-filled panels and borders painted in a thin watery blue were aimed at European taste. Later the quality improved and some attractive and elegantly shaped porcelains decorated with well-composed designs of Chinese figures, flowers and landscapes painted in a strong clear blue appeared on the market. During the eighteenth century polychrome overglaze painted wares were added to the blue and white porcelains as the Chinese had developed new techniques. For convenience these techniques have been classified as *famille verte* and *famille rose* in which a fresh bright green and a rose pink in varying shades respectively dominated the colour scheme. *Famille verte* for the export market was often made into sets – *garniture de chemine* – of three jars with lids and two flaring beakers

which could be displayed effectively on the mantelpieces and sideboards of European homes.

It was an obvious step to pass from designs adapted to European taste to direct copying of original engravings and prints. Here the varied and subtle palette of the *famille rose* porcelains lent itself well to the copying of pastoral and narrative scenes, incidents of the Christian religion and classical mythology, and eventually armorial devices on dishes and containers shaped to the requirement of European eating habits. The earliest examples yet known of armorial wares are late seventeenth century blue and white pieces but later *famille rose* dominated production. The armorial porcelain trade reached its height in the eighteenth century and was controlled by the Honourable East India Company which had been founded in 1600 by a group of enterprising British merchants and competed with the Dutch for the Far East trade throughout the seventeenth century. By 1700, however, it was successful in obtaining a base at the southern port of Canton through which it handled all the trade in export

58 Pair of majolica candlesticks, a salt and a plate, Crathes Castle.

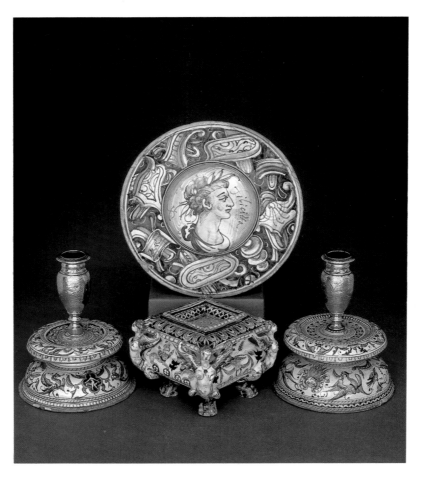

porcelain for the British market. Customers required considerable patience as they could wait up to three years for their services to be completed and delivered. The order would be brought to China by one of the East India Company's ships and would be made and decorated at the long-established factories of Ching-tê-Chên which produced wares for both Chinese and export markets. The completed services were then taken down river to Canton for loading which took place from October to March. Usually the first shipment was ready for sale by November, but much depended on having satisfactory weather conditions especially favourable winds. Later in the eighteenth century the overglaze painted decoration was added at Canton which streamlined the operation. Despite the hazards and delays, however, the demand for Chinese armorial services did not abate as they so excellently fulfilled their function that they were well worth the long wait.

Both English and Scottish families were eager to possess armorial porcelain. Originally the majority of services were

59 Pair of Meissen *bocage* candlesticks, Brodie Castle.

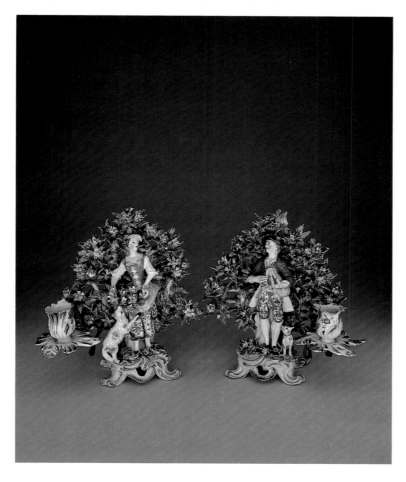

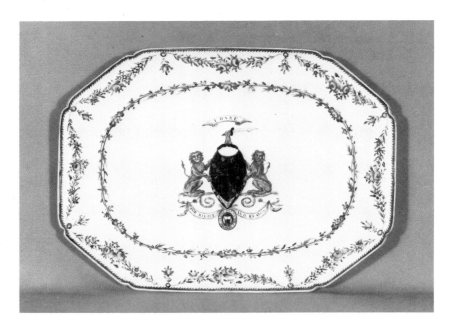

60 Chinese armorial ashet,
1773, The House of The Binns.

destined for the English market as the East India Company
trade at first was concentrated in the hands of London mer-
chants. By 1745, however, nearly 20 per cent of the orders
were for Scottish families. After the 1745 rebellion this per-
centage declined as potential Jacobite customers fled the
country leaving mainly Hanoverian supporters to commis-
sion services. As more stable political conditions were estab-
lished Scottish families were in a position to extend and
embellish their homes and enjoy a more sophisticated social
life with its accompanying material comforts and refinements
which included fine Chinese porcelain. It is from the latter
half of the eighteenth century, therefore, that the armorial
services in the National Trust's houses date. They are inter-
esting both in the context of family history and as examples
of the styles of export porcelain then in production.

By the late eighteenth century the Chinese had reduced
the decoration on the *famile rose* services to a few simple
easily reproduced formulae – borders of flower festoons,
scrolls and shells, chains, ribbons, sprigs of European-style
flowers – all forming a versatile scheme into which the
individual owner's arms could be included. The handsome
dinner service commissioned as a wedding present for Sir
Robert Dalyell, 14th Baronet, in 1773 which can be seen at
The Binns shows this style well. (Plate 60) Within attractive
enamelled floral borders is the family crest of the Dalyells
and their motto I DARE FOR RIGHT AND REASON framed
by supporting figures. A similar treatment is found in the
part service of the Irvine family of Drum. Here the coat of
arms and the motto SUB SOLE UMBRA VARENS (The

changing shadow under the sun) painted in opaque colours are framed in supporting figures. A variation on the *famille rose* decorated wares is the service from Castle Fraser which is decorated *en grisaille* in gold framing the arms and motto LUCEO NON URIS DATA FATA SECTUS (I shine but do not burn following what Fate decrees) of Francis Hunberstone Mackenzie, First Lord Seaforth (1754–1815) for whom the service was made. As in the Dalyell and Drum services the arms are supported by a pair of naked figures holding a club and arrows. An unusual and lively piece from Drum Castle is an eighteenth century rectangular tea tray in blue and white porcelain skilfully painted with a classical scene – the Judgement of Paris – copied from a European engraving. (Plate 61) It is a good example of how the Chinese could accurately and deftly cope with alien designs and also of the taste for classical themes then fashionable in Europe. The family motto FOY POUR DE VOIR has been neatly added at the upper border. One of the most interesting of the armorial services is the large and splendid one at Brodie

61 Chinese armorial porcelain tea tray, Drum Castle.

Castle in blue and white porcelain which included 102 dinner plates and three large soup tureens (Plate 62). This may be dated to about 1800–1805 on historical and stylistic grounds. By the late eighteenth century the Brodie family were in financial difficulties and to make some effort to restore their fortunes James, son of the 21st Laird, went to India in the employ of the East India Company. His uncle Alexander Brodie had already become wealthy serving in the Indian army and doubtless encouraged his nephew to try his luck in

62 Chinese armorial soup tureen, Brodie Castle.

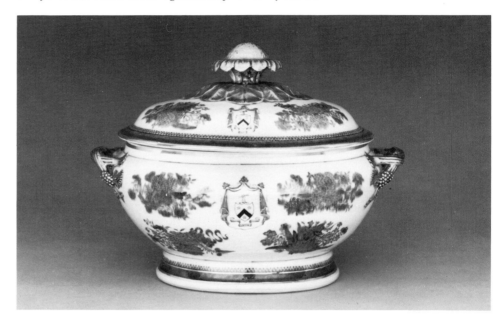

63 Tea-pot, teacup-and saucer, Derby c. 1815, The House of The Binns.

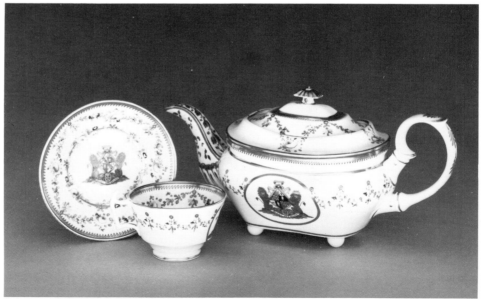

India. James prospered sufficiently to build himself a home 'Brodie Castle' at Madras in 1796 but his career was cut short by his death from drowning in 1802. Although there is no direct record of the armorial service being ordered at this time, the Brodie connection with Indian service makes it likely. Alexander Brodie had the wealth, contacts and established position to require such a service: he had married a niece of the Earl of Wemyss and had become Member of Parliament for Elgin. In type the service is an example of the revival of blue and white for armorial wares at the end of the eighteenth century decorated with designs of peony sprays and floral borders the so-called 'Fitzhugh' style. The family motto incorporated in the armorial bearings is UNITE which one of the tureens has been painted as UNTIE showing the kind of mistake a Chinese painter could make when copying a language and script unfamiliar to him.

The Brodie service is also significant as it falls within the last group of armorial porcelain to be manufactured. From the early nineteenth century onwards the trade in Chinese armorial porcelain was to decline mainly because of increasingly successful competition from European products. If European ceramic factories could make and promptly deliver wares of a quality to match the Chinese services and undercut them in price, it was not worth a customer's trouble to place an overseas order. This is well illustrated by the collections at The Binns. When the Dalyell family wanted to extend their family service *circa* 1815 they no longer sent an order to China but instead commissioned a tea and coffee set with coat of arms and decoration as on their eighteenth century service to be made in soft-paste enamelled porcelain at the Derby factory (Plate 63). The result closely matches the Chinese original. Apart from the distinctive armorial services, the Scottish houses also commissioned other types of Chinese wares in large quantities such as the 128 pieces at The Binns of the attractively decorated eighteenth century blue and white porcelain which had always formed the mainstay of the export trade. Brodick Castle has two *famille rose* export pieces, a handsome goose tureen of late eighteenth century date (Plate 64) and a topical Scottish piece – a souvenir plate whose design of two kilted Highlanders was copied from two prints commemorating the mutiny in 1745 of the 42nd Foot Regiment.

Collections of export ware are to be expected in great homes because they so admirably fulfilled the practical requirements of a large European household. There was, however, a more conscious and informed taste for Chinese artefacts in eighteenth century Europe based on a blend of wonder at a seemingly exotic culture and a genuine admiration for Chinese achievements in the arts. In architecture

this taste is seen for example in Sir William Chambers' large pagoda of 1761/2 at Kew Gardens and in an enchanting Chinese pavilion at Drottningholm built to celebrate the birthday of Queen Ulrika of Sweden in 1753. On a more intimate scale this pleasure in Chinese art was shared by the colourful eccentric and collector William Beckford (1760–1844) whose vast wealth enabled him to indulge his excellent taste. The marriage of his daughter Euphemia to Alexander, 10th Duke of Hamilton, ensured that some of his collection

64 *Famille rose* goose tureen with silver mounts, Brodick Castle.

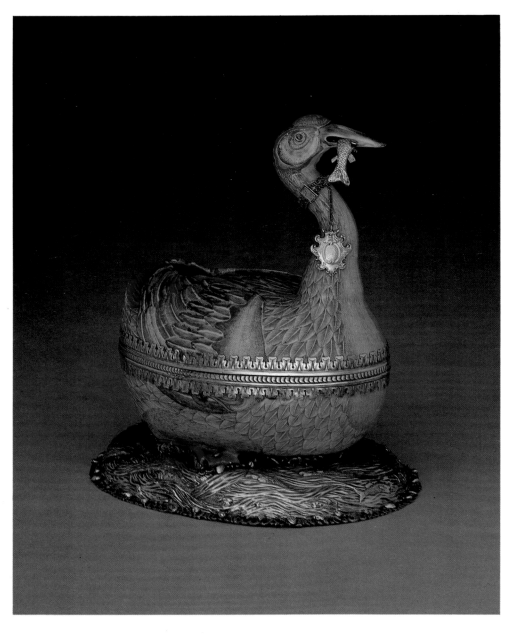

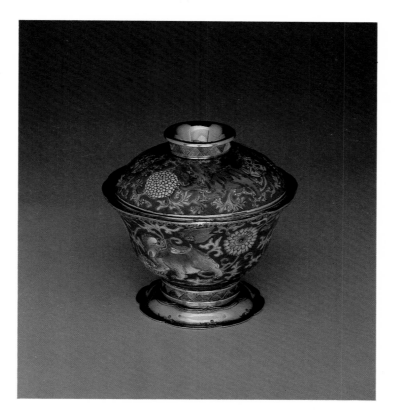

65 A porcelain bowl and cover with silver-gilt mounts, Brodick Castle.

is now housed in Brodick Castle. It includes some exquisite late eighteenth century Chinese porcelains – delicate bowls, and cups of plain *blanc-de-chine* and enamelled in overglaze colours with designs of floral sprays and carefully drawn Chinese figures reflecting a more Chinese taste than that represented by the commercialised products of the armorial market. (Plate 65) All the Beckford pieces are set in tasteful silver mounts which he designed himself. At a later date another Scottish house possessed a collection of porcelain assembled through a connoisseur's interest rather than family need. The seventeenth century house of Hill of Tarvit was bought in 1904 by F. B. Sharp who commissioned Robert Lorimer to adapt the house to display his extensive collection of fine seventeenth and eighteenth century Chinese and Japanese export porcelain and bronzes.

JENNIFER SCARCE

Further Reading

Franklin Barrett, *Derby Porcelain 1750–1848* (1971)
David Howard, *Sanctuary, Chinese Armorial Porcelain* (1974)
David Howard and John Ayers, *China for the West, Chinese Porcelain etc, The Mottahedeh Collection* (1978)
Margaret Medley, *The Chinese potter* (1976)
Bernard Rackham, *Catalogue of Italian Maiolica* (1977) 2 vols.

Country House Furniture

The furniture in the collections of the National Trust for Scotland has been acquired in a number of ways. The most obvious is when a house is accepted by the Trust together with what is loosely called 'essential furniture and furnishings'. In the early days of negotiations it is of the utmost importance that as much of the original furniture as possible be acquired, this is particularly so with an important period property such as Culzean. Having said that, I can hear people commenting on how acquisitive the Trust is. Looked at logically, however, the furniture is part of the architecture of a house, and therefore, as far as possible, house and furniture should be kept together. Houses such as Brodie contain such a splendid variety of furniture, pictures and decorative items that the aim is always to acquire as much as possible so as to be able to show the house off really well with no gaps – provided, of course, and this is where I play devil's advocate – that the donating family are entirely happy about the arrangement.

The second way of increasing and improving the collections is by gift or bequest. Many generous benefactors have come forward and helped the Trust enormously in this way. They usually want a good home for their possessions and cannot bear the thought of them being disposed of in the saleroom. There is the added safeguard in such cases that a gift can be declined on the grounds of its unsuitability and this does happen from time to time. It is far more satisfactory for the donor to know that their gift is being appreciated somewhere and not collecting dust in a store.

The third method of acquiring is by purchase. The Trust has two special funds, the Contents Fund, and the Ardmore Fund, both specially set up for the purchase and improvement of furniture and furnishings. In addtion, application can be made to the Museums Purchase Fund which is administered by the Victoria and Albert Museum, and also to the National Art-Collections Fund which now has a special Scottish Fund. It was through these two that the tapestries in the Chapel Royal at Falkland were acquired in 1980. Inevitably there are gaps in the Trust's collections and it is a

Curator's task to be constantly on the look out for sympathetic additions – additions that look as though they have always been there. Over the years many purchases have been made to the greater embellishment of the properties, indeed the quest for improving the collections for future generations continues. For the sake of clarity and convenience I have divided the furniture into four groups.

By far the most important group of early vernacular furniture is to be found at Crathes Castle, Kincardineshire. It is of particular significance because it is still in the house for which it was made, and on account of its strong stylistic character, it can fairly confidently be attributed to the Aberdeen School of woodcarvers which flourished from the middle of the 16th century until the last quarter of the 17th century. It is often suggested that these early pieces were made on the estate but the elaborate carving of the great bed at Crathes made in 1594 for Alexander Burnett and his wife Katherine Gordon, and bearing their arms, shows far too high a degree of sophistication to have been made locally.

66 The chairs of Alexander Burnett and Katherine Gordon, Crathes Castle.

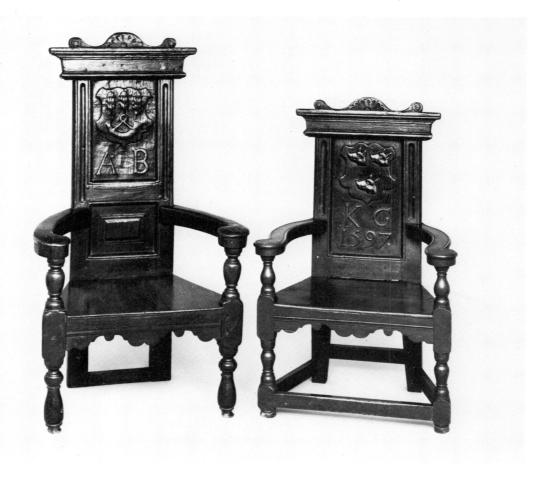

Two chairs at Crathes belonging to this early group also exhibit typical characteristics of the Aberdeen School. (Plate 66) This is particularly evident in Alexander Burnett's chair with its tall narrow back, the moulded arcaded cresting rail and the way in which the arms appear to grasp the sitter. The second chair, made for Katherine Gordon, and bearing the date 1597, has a lower back, but is of similar form, but the arms in this case sweep outwards, as if to allow easy access for a woman wearing the full skirts of the time. Both chairs are carved with their respective family devices and are of oak and fir, and are clearly en suite.

Further items of furniture having strong vernacular characteristics are also to be found at Crathes. They are later in date, and are not nearly as sophisticated as the pieces already mentioned. In particular, attention should be drawn to the delightful betrothal chair, the back carved with hearts, initials and simple primitive devices. It would appear to date from the early 19th century. A group of three children's chairs almost tell the story of chairmaking in the Georgian era in miniature. One is George I in feeling, with its plain splat, another has a pierced splat echoing the designs of Thomas Chippendale, and both these have the slightly inward curving arms that are characteristic of the Scottish vernacular tradition. The third chair dates from the early 19th century. It retains the vestiges of inward curving arms, and in addition, the back is decorated in much the same way as a chair for an adult would have been.

Another simple honest piece in the same house is the Buchan dias, which is a settle, with a difference, having a flap in the centre which when lowered forms a convenient table. It would have had no place in a castle, but would undoubtedly have been a common enough item in a farmhouse kitchen in North East Scotland.

Much of the remaining furniture at Crathes has been added over the years, particularly since the disastrous fire of 1966, either by purchase or bequest, but care has been taken to maintain the idiom. The most important addition being the marquetry cabinet in the Gallery. (Plate 67) Its walnut veneered surfaces are enriched with marquetry panels beautifully inlaid with floral motifs. It is English, dating from about 1685 and is reputed to have come from Studley Royal, in Yorkshire.

Castle Fraser boasts one early 17th century arm chair which by tradition came from Falkland Palace, the back panel and cresting rail are carved with a simple all-over design. It is not of the same quality as the early Crathes chairs, and the lower back would indicate a more Southern provenance. The High Hall and Anteroom at Castle Fraser contain further good examples of early furniture, in particular a set of late 17th

century chairs from Inverallochy Castle, Aberdeenshire. They are typically provincial, made of local woods, and lack the cane seats and back panels of more refined types, these being replaced with vertical rails, some of wavy form. Dished seats were provided to take a squab.

Hill of Tarvit, a modest country house remodelled by Lorimer at the beginning of this century, and designed to take a varied and interesting collection of works of art, has, as its centre piece, a baronial hall furnished with an inter-

67 Late seventeenth century marquetry cabinet, Crathes Castle.

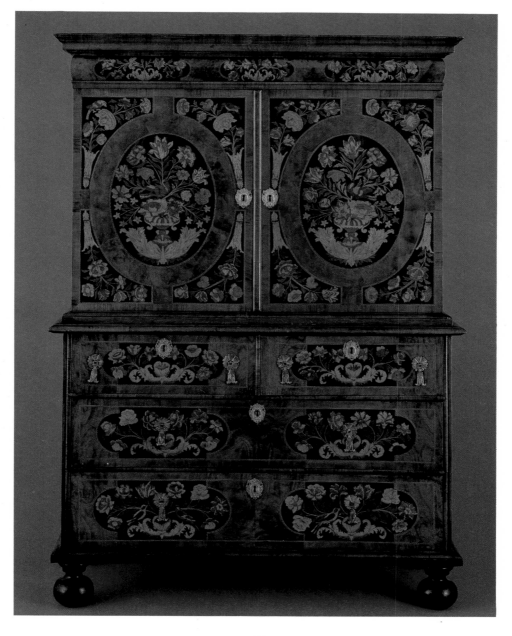

esting collection of 17th century armchairs of varied provenance, some of them oak and fir, some undoubtedly Scottish.

The only other property where early furniture is displayed is Gladstone's Land in Edinburgh. The first floor of this merchant's house, completed in the early 17th century, has an elaborate painted ceiling in the principal chamber. This together with two other small rooms immediately behind, has been furnished with 17th century, and where possible, with vernacular items. The great bed, dating from the early 17th century, belongs to the Aberdeen School and shows similar characteristics to the one at Crathes. The large armoire of Dutch provenance is the sort of piece which is still commonly found in many houses on the Eastern seaboard of Scotland. They were imported from the Low Countries from the 17th century onwards. The Little Chamber, at the rear of the building, contains two Scottish chairs, of early 17th century date. One came to the Trust by gift, and the other was a rare purchase. They are undoubtedly of the kind that would have been used in a house such as this.

The early years of the 18th century are well represented in the Green Parlour at Gladstone's Land. The simple painted panelling is a subtle foil for the collection of furniture which has been gathered together from various sources; the side chairs come from Leith Hall and of them a set of three have drop-in seats and their construction would indicate Scottish provenance, judging from the way the knee joins the seat rail. They are boldly executed in walnut and have generous block turned stretchers. The mahogany centre table with cabriole legs and paw feet, is surely the most handsome piece in the room and shows the final graceful development of the gateleg table. It was a type which remained justifiably popular throughout the 18th century, but which lost its elegant lines on the introduction of the straight leg later in the century.

Drum Castle can boast a really splendid piece of early Georgian furniture. It is a bureau on cabriole legs on which stands an enclosed cabinet surmounted by a curved broken pediment, all of solid yew-tree. It has simple pierced handles which by great good fortune have survived. Over the years it has been cared for lovingly and today it is in immaculate condition.

Amongst the many treasures at Brodie are some good examples of lacquer furniture, in particular an English William and Mary double domed cabinet with flambeau finials. (Plate 68) It opens to reveal an array of drawers and secret compartments, and the top drawer of the lower part is fitted as a secretaire. It is on display in the Best Bedchamber together with a pair of Oriental lacquer cabinets of early 18th century date. On the main staircase at Brodie stands an

English lacquer longcase clock with the movement by Robert Clidsdale of Edinburgh.

At Haddo the only item of furniture belonging to the early 18th century is a mahogany silver table with characteristic tray top, and with the added refinement of decorative brass inlay (Plate 69) For many years it was hidden away in the basement in several pieces and having survived a flood, was finally discovered and rescued by the Trust. Now painstakingly restored, it can be seen in the Anteroom.

The dining room at Hill of Tarvit was designed early this century with a decidedly Palladian feel to accommodate a general collection of 18th century furniture. The chairs – a harlequin set – are in the manner of Thomas Chippendale. The table, although much later, is a very fine example of an imperial dining table patented by Gillows of Lancaster in the early 19th century. Part of a set of Chippendale chairs of high quality and originally at Farnham Castle, formerly the home of the Bishop of Winchester, came to the Trust with the gift of Malleny and are now at Hill of Tarvit.

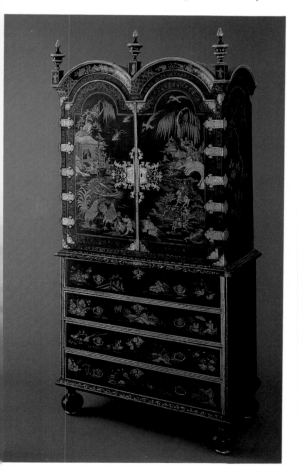

68 Late Stuart lacquer cabinet, Brodie Castle.

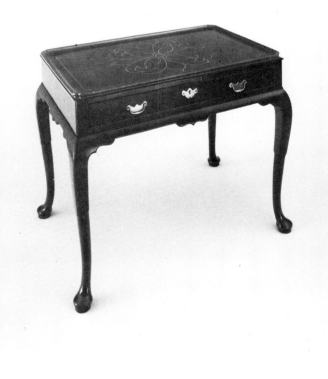

69 Early eighteenth century silver table, Haddo House.

An exotic note is struck at Brodick with the marvellous set of three pairs of Venetian stools in the form of Blackamoors. They originally belonged to William Beckford, that great eccentric and connoisseur, and once graced Fonthill Abbey. The Binns also boasts a pair of standing Venetian Blackamoors which have retained the Doges device on the plinth. (Plate 70)

At Culzean the walnut longcase clock by George Graham is a real treasure. The case was made by Thomas Wall of Richmond, and the number of the movement is impressed on the thickness of the door in the trunk.

The last quarter of the 18th century is well represented but in a comparatively modest way. Robert Adam had returned to his native Scotland in the 1770s and was soon to be remodelling Culzean for the 10th Earl of Cassillis. The overcrowding of old Edinburgh and the more settled political conditions led to the building of the New Town. With the improvements in agriculture even the humbler dwellings were beginning to be more permanent and were being furnished with better pieces than hitherto, simply made and generally reflecting the designs of furniture of more well-to-do establishments. The furniture of this period can therefore be conveniently divided into three groups.

For Culzean, Robert Adam designed not only the chimney pieces but also chimney glasses, pier glasses, and girandoles for which drawings exist, dated 1782. Although little of the original furniture supplied for the house survives, some can, with reasonable confidence, be attributed to his designs on stylistic grounds, notably the hall chairs, a pair of half circle inlaid pier tables, and some of the chairs in the Saloon. Some of the later additions include a distinguished pair of satinwood commodes now in the Picture Room. (Plate 71) On account of the cabinet work they are attributed to Charles Elliot, who made similar furniture for Langleys, in Essex.

The Georgian House in Edinburgh has been furnished as a professional man's house and although it contains furniture of good quality, there is nothing spectacular. A positive attempt was made to acquire furniture with an Edinburgh provenance and amongst such pieces worthy of mention is a refined tea-table bearing the stamp of Bruce and Burns who were working in Edinburgh at the end of the 18th century and beginning of the 19th century; it has the added interest of retaining the tinned tea boxes in the frieze drawer. The square piano was also made in the city but the barrel organ and the globes were made elsewhere, only their trade labels indicate that they were bought locally.

For the contemporary cottage interior the Bachelors' Club at Tarbolton is probably the best example. The only room

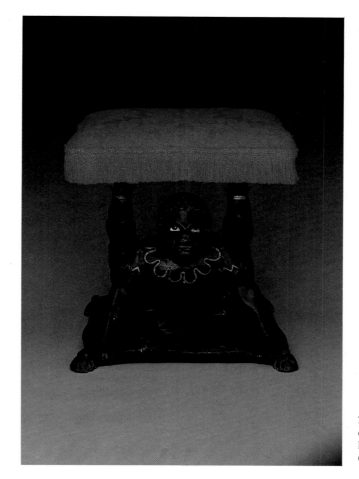

70 One of a set of late eighteenth century Venetian Blackamoor stools, Brodick Castle.

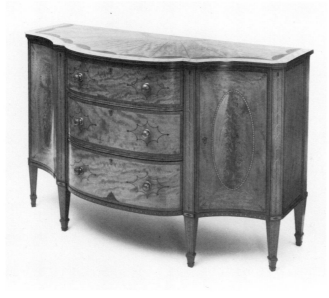

71 Late eighteenth century satinwood commode, Culzean Castle.

contains simple country Chippendale chairs, a delft rack and a press – all straightforward and honest, these are the country joiner's interpretation of town furniture in local unsophisticated woods. (Plate 72)

Apart from a set of Louis XV fauteuils, covered in Beauvais tapestry at Culzean, and the superb commode at Brodick signed by Louis Boudin, the only other pieces of high quality French furniture in the Trust collections are at Hill of Tarvit and at Brodie. At the former, the Drawing Room was especially designed to accommodate the French furniture which mostly dates from the last quarter of the 18th century, although the important commode there is later. It was made by Adam Weisweiller, a celebrated *ébéniste* who studied in the workshop of David Roentgen, later working for Daguerre, and supplying furniture for the Royal Palaces, and continuing to work through the Revolution. An earlier, and important

72 The Bachelors' Club, Tarbolton.

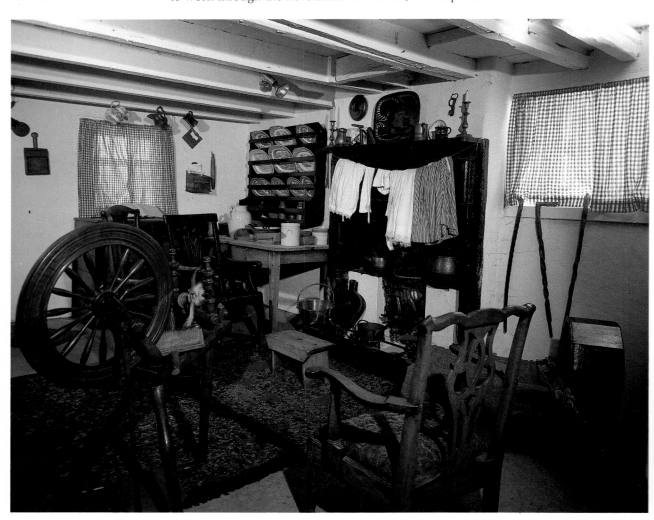

item, is the *bureau plat* in the same house, made by J. C. Saunier, who was a brother of the more celebrated Charles Saunier. It is veneered in kingwood, and bears the maker's stamp underneath.

The Louis XV furniture at Brodie includes a *bureau plat* of very high quality by Jean-Baptiste Hédouin, a fine maker who became *maître ébéniste* in 1738. The other exceptional piece is the *table a dessus coutissant* – a bed table that can be put to a variety of uses. (Plate 73) These pieces came to Brodie through the Duchess of Gordon, who was a Miss Brodie before her marriage to the 5th Duke.

The 19th century is represented at Brodie where, following the alterations carried out by William Burn in the 1820s, new dining room furniture was purchased, and later, in the 1840s a new library was created out of two store rooms and furniture of that period was bought.

73 *Table a dessus coutissant* or 'bed table', Brodie Castle.

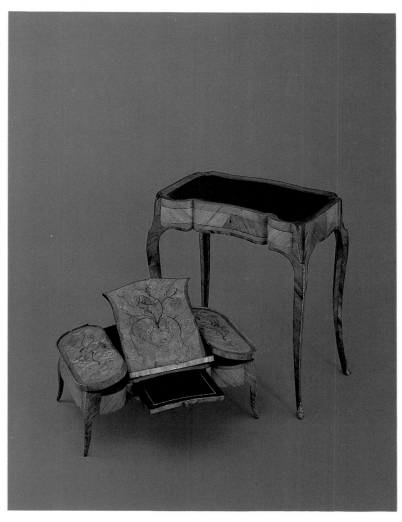

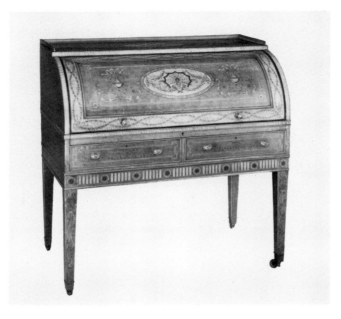

74 Cylinder desk by Wright and Mansfield, Haddo House.

In 1880 Haddo House was almost completely refurbished by the London firm of Wright and Mansfield. They supplied nearly all the furniture for the reception rooms, all in the Adam Revival style, and of very high quality, as one would expect from such a firm. (Plate 74) A great many pieces bear either their stamp or trade label. The dining chairs, however, in similar style, were supplied by Turner, Lord and Company, another London firm. The Library, still remarkably complete, combines Victorian comfort with Adam style elegance.

Finally, mention should be made of Robert Lorimer, who in addtion to being an architect, designed furniture and fittings with great accomplishment. Whilst living at Kellie, he employed one William Wheeler, a local joiner living at Arncroach to make furniture for him – it was a happy and fruitful relationship. Whytock and Reid of Edinburgh made a great deal of furniture to his designs. In addition to his own peculiar Gothic style, he was also influenced by the graceful designs of Queen Anne furniture and sometimes he went a step further by combining it with a French Provincial flavour.

DAVID LEARMONT

Further Reading

Victor, Chinnery, *Oak Furniture – the British Tradition* (1979)

John Gloag, *A Social History of Furniture Design to 1960* (1966)

Percy Macquoid and Ralph Edwards, *Dictionary of English Furniture* (1954), 3 vols.

Jean Nicolay, *L'art et la Manière des maîtres ebénistes francais au dix-huitième siècle* (1956–59), 2 vols.

Peter Savage, *Lorimer and the Edinburgh Craft Designers* (1980)

Picture Collecting in Scotland

'Now is the time to go to the Continent and buy good pictures', wrote Lord Eldin in the opening decade of the 19th century, 'for Sir John Dalrymple has bought all the bad ones'.

The remark is probably less important as a commentary upon the picture collection which Sir John Dalrymple had just formed at his new house of Oxenfoord than as a statement of the permeation of taste at the end of the 18th century to all the moneyed classes of Scottish society. A century earlier, it would have been hard to conceive of great collections let alone great connoisseurship being exhibited by any in Scotland other than the aristocratic land-owners. Yet the century of the grand tour, the century of industrial, agricultural and commercial growth not only extended taste and acquisitiveness to the professional and business classes, but also made it possible for them to satisfy their ambitions to act the patron.

To some extent the very framework of the Scottish country house acted against the enjoyment of a collection of fine paintings. The tower house with its thick defensive walls and small windows scarcely provided the best of viewing – or indeed of conservationist – conditions. Rooms themselves tended to be not large and often those that had any claim to scale – like the Hall of Craigievar – were embellished upon their wall-surfaces with plaster decorations. Nevertheless collections there were, and often collections of size. An early inventory from Castle Fraser records nine paintings in the drawing room, 16 in the Little Dining Room, 26 in the Hall and four more in 'Colin's Room'; sadly we have little possibility of establishing what all these were.

Clearly, however, the earliest collections of paintings within the great house in Scotland were the pious records of inter-family liaison or of loyal support of the type familiar in the contemporary family power-base in England. Where at Hardwick an Elizabeth the First looks from the Gallery walls, so at Falkland, although itself a royal palace, do the images of King James VI and his Queen Anne of Denmark. (Plate 75) From surviving house-lists it is clear that several of the ancient Scottish families – the Campbells, the Kers and

others – displayed iconographies of the Scottish royal line, and houses like Taymouth or Castle Grant were obvious focal points of family influence at which to display portraits of kinship alliance or political friends.

The acquisition of paintings from Europe, paintings to be enjoyed for their aesthetic merit, gained strength in Scotland in the second half of the 17th century. An old sale-bill of 1697 advertises for sale in Edinburgh – in fact in Gladstone's Land – 'A curious collection of pictures of all sorts and sizes, some

75 *James VI as a Young Man,* Falkland Palace.

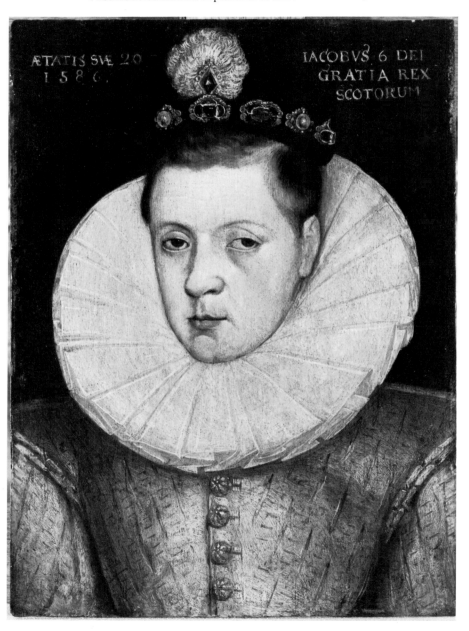

fit for halls and staircases, others for chambers and closets'. From documentation like this, and one or two later inventories recording earlier purchases, one can make one or two generalised observations. The reference above to 'closets' reminds us that a favourite mode of collecting was to acquire small panels or canvases of a sort most suited for the private rooms in a house rather than for the great public parade-grounds; the word 'closet', incidentally, which so frequently appears in the inventories of the time was later transformed under French taste to 'cabinet' – the study, perhaps, of today. So – in the 1720s – John Alexander was called in to 'appreciate' the pictures hanging in 'My Lord Annandale's Closet' at Craigiehall – and from the number of them, they must have been relatively small.

We can also see quite clearly the direction of collecting taste at this time – a taste for the paintings of the Low Countries and northern France. The little Dutch river scenes at Hill of Tarvit, though obviously part of a collection formed much later, nevertheless typify the sort of subject matter as

76 Frozen River Scene,
Avercamp, Hill of Tarvit.

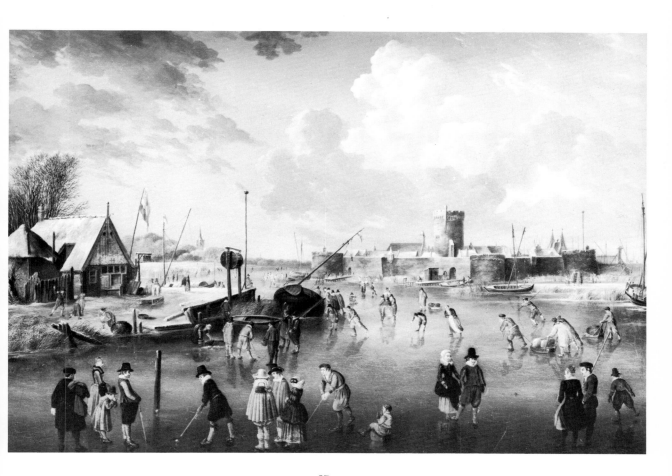

97

well as scale in vogue among Scottish late 17th century collectors. (Plate 76) The Dukes of Hamilton, the Kers of Lothian and the Clerks of Penicuik were all among the founding-fathers of Scottish picture collecting and the role of John Clerk of Penicuik, merchant in Paris, not only in forming his own collection but also in supplying paintings to others, can scarcely be over-stated. 'I have bocht from Lopez the two pictures for your Lo'p for 226 livres', he writes to Lord Lothian in 1645; 'he would not remit a farthen off the pryce first on his book'.

In this emphasis of interest upon the Dutch School, in the 17th century, Scottish collectors were responding more to the conventional direction of Scotland's ties with Europe rather than to any pre-conceived notions of taste. It was logical to follow the road already established by Scottish traders to the cities of the Netherlands or by Scottish men of letters to the Dutch universities. The revolution of taste, the discovery of Italy and of the rich collections of Rome, Florence or Bologna followed upon the enlightenment of the Grand Tour of the 18th century. Joseph Addison's *Remarks on the Several Parts of Italy* of 1707, or Jonathan Richardson's *Account of the Statues, Paintings and Bas-Relievos that are to be found in Italy* of 1722, are just two examples of the many travel books of the time that helped to awaken interest in a picture-buying tour to the Mediterranean.

The 2nd Marquess of Annandale who went out from 1718 to 1720 was an early buyer although, perhaps, not a particularly well-informed one and the cargo of almost 300 works of art with which he returned is remarkable more for its spirit of optimism than for its understanding. Understanding came later and undoubtedly was assisted by the advice of men like Thomas Jenkins, James Byres or the painter Gavin Hamilton, all resident in Rome and all ready, as 'antiquaries', to assist the moneyed traveller to form his taste and lay out his resources. Thus guided, some Scottish aristocratic travellers formed collections of cardinal importance in the development of taste – such as, for example, James Grant of Grant who distinguished himself as an early patron of Neoclassicism. Lord Haddo was another such 'grand tourist' and his superb portrait by Pompeo Batoni not only demonstrates his own judgement in selecting an artist of this merit but also stands as an archetypal monument to the Grand Tour as a whole. (Plate 77) Where the patrons went, their artists followed and many an 18th century Scottish painter – Alexander Runciman, David Allan, Allan Ramsay – owed his early training in Italy to the discrimination of these Scottish patrons. Allan Ramsay, whose delicacy in portraiture was to lead Walpole to remark that he was born to paint women (as Reynolds men), in fact made four visits to

Rome and paintings like his *Mrs Mure of Caldwell* at Hill of Tarvit show quite clearly that he learned not only a delicacy of approach, hard to recognise among his early contemporary painters in Scotland, but also a technical fluency deriving from his contacts in Rome and Naples certainly but above all in Venice. (Plate 78)

At the same time the Scottish domestic interior had changed. Large, well-lit rooms, plasterwork receding to the status of formal wall-panels, – these and other manifestations cleared the way for the buying and showing of fine new acquisitions of scale. At the same time the 'continued fire-place', the architecturally contrived over-mantel, became out-moded and it was essential to find suitably important alternative decorations to go above the mantel, the focal point of all eyes on entering a room! Some chose mirror-glass in elaborately carved and gilded frames; but for many the need was for large and dramatic paintings. This is the role for which Alexander Nasmyth's great landscapes at Culzean might well have been conceived. So typical of their

77 *Lord Haddo*, Pompeo Batoni, Hàddo House.

78 *Mrs. Mure of Caldwell*, Allan Ramsay, Hill of Tarvit.

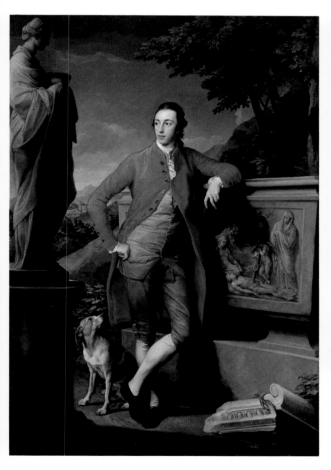

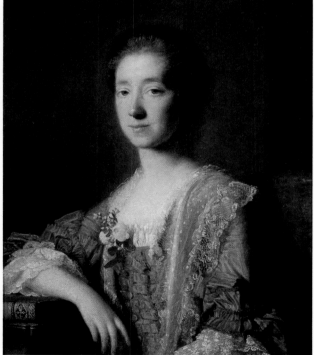

period, they could only have been painted by a man who himself had travelled south to see at first hand the arcadian inspiration of a Claude. (Plate 79)

Now art collecting in Scotland takes off. More money, an increasing bank of pictures for sale, an increasing knowledge of the schools of Italy – these factors introduce the joys of acquisition to the new wealth of Scotland. As an interesting illustration of who the new buyers are one can scan the purchasers' names at the sale of Colonel Charteris's pictures in 1732. John Medina and John Alexander, as painters themselves, one might predict, although possibly they were acting as buyers' agents; but elsewhere there are Mr Ross and Mr Stewart, both merchants in Edinburgh, Mr Granger a writing-master, Mr Cave a brewer, and Mr Hugh Dalymple an advocate. Later Walter Ross, a Writer to the Signet, John MacGowan a banker and Robert Alexander an insurance broker all form collections of note and discrimination. This is important in two ways: first, it establishes in Scotland a vast and circulating reservoir of pictures from which even

79 Culzean Castle From the Sea, Alexander Nasmyth, Culzean Castle.

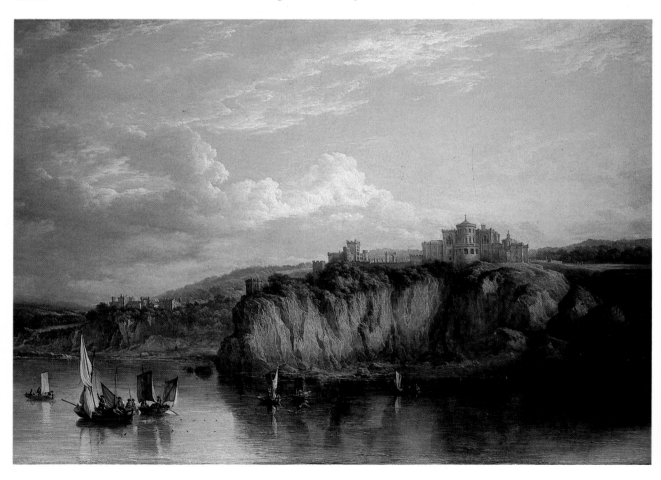

those unable to travel to the markets of Europe can buy; secondly, it is from this very reservoir rather than from the aristocratic land-owners' collections, frozen as it were by entail, that the public collections of today were originally formed. Middle-class taste in 18th century Scotland is a field deserving closest scrutiny, and while the informed and *avant-garde* taste of men like Lord Aberdeen, an evangelist of the neo-Greek, is recognised for its importance generally, the objects on which he lavished this taste have remained a

80 *4th Earl of Aberdeen*, Sir Thomas Lawrence, Haddo House.

family perquisite, only recently to be enjoyed by a wider audience through the present ownership of Haddo by the National Trust for Scotland. (Plate 80)

The options for purchase by the 19th century Scottish connoisseur were immense. Regular sales in Edinburgh, Glasgow and Aberdeen, let alone London, equally regular visits north by London dealers – like Woodburn or Pinney coming to Edinburgh, and also the possibility of buying contemporary art offered through annual exhibitions (from

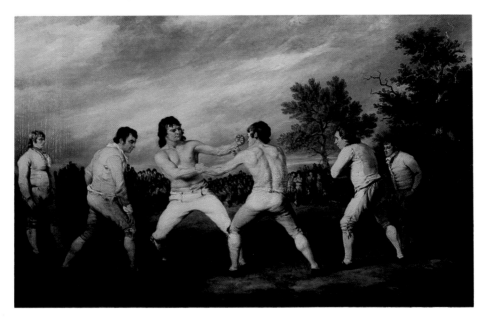

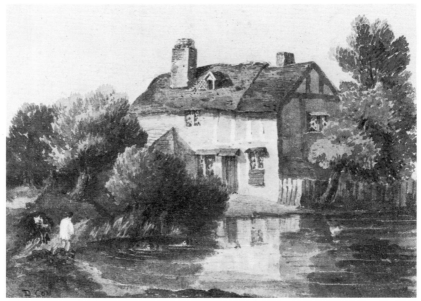

1808) – all these facilitated the formation of new and vast collections. Now a further extension of collecting practice takes place; there are new men of wealth and the characteristic of many important collections of the 19th century in Scotland is that they were formed not by the bankers or lawyers of the Capital but by the industrialists of Clydeside or Tayside. The Ewings, the Reids, the Orchars had their own quite distinctive likes or dislikes and it is the stamp of these highly individual personalities that today makes a visit to Dundee, Broughty Ferry or Glasgow so worth while.

But idiosyncracy in collecting was not limited to these collectors. One of the most interesting and specialised collections in Scotland is the gallery of sporting art that Brodick Castle can show. Formed partly by the sporting 12th Duke of Hamilton – of whom, they said, that he lost more money on the racetrack in a year than most men earned in a lifetime – this is a record not only of sport but of sporting painting which has no rival in Britain. Painters like Herring, Pollard and Reinagle are represented in scenes that sometimes have a Hamilton connection, sometimes not, but which always combine an artist's vision with an undoubted accuracy of record. (Plate 81)

The Brodick sporting collection could be described as extrovert! Never so the paintings brought together at Brodie where a family taste extended in late 19th and early 20th century purchases demonstrates two tendencies in latter-day collecting. We return, perforce, to small scale art – the domestic qualities of the English water-colourists like David Cox or Francis Wheatley – the sort of pictures suited to a retracting domestic environment; and what we enjoy is of course the stamp and personality of one family's taste, or indeed that of one member of a family. (Plate 82) This was a taste lavished with a particular house in view; in a sense paintings, rooms and the *persona* of the collector are inseparable, and if this inseparability can be continued for posterity to enjoy through the medium of Trust policies, then an important and dramatic element in Scottish picture-collecting can be saved.

BASIL SKINNER

81 *A Prize Fight*, Reinagle, Brodick Castle.

82 *A Cottage Scene*, David Cox, Brodie Castle.

Further Reading

Arthur Foss, *Country House Treasures* (1980)
James Holloway and Lindsay Errington, *Catalogue, The Discovery of Scotland* (1978)
David and Francina Irwin, *Scottish Painters at Home and Abroad* (1975)
Basil Skinner, *Catalogue, Scots in Italy in the Eighteenth Century* (1966)

NOTES ON CONTRIBUTORS

Michael Clayton joined Christie's silver department in 1959 and in 1972 opened their Scottish office in Edinburgh. He is the author of *Collector's Dictionary of Silver and Gold of Great Britain and North America* (1971)

David Learmont joined the National Trust for Scotland in 1970 as Curator. His department of four looks after the interiors and contents of all properties in the Trust's care. He has been particularly associated with the historic rehabilitation of Culzean, and the furnishing of the Georgian House and Gladstone's Land. He is a founder member of the Furniture Society (1964) and a Fellow of the Society of Antiquaries (1981).

Rosalind K Marshall has been since 1973 Assistant Keeper in the Scottish National Portrait Gallery. She is the author of *The Days of Duchess Anne* (1973), *Mary of Guise* (1977) and also arranged the exhibitions *Childhood in Seventeenth Century Scotland* and *Women in Scotland* and wrote the catalogues.

Alistair Rowan is Head of the Department of the History of Art in University College, Dublin. He was a member of the Council of the National Trust for Scotland, and closely involved with Culzean and The Georgian House. He is author and editor of the Penguin Books *Buildings of Ireland* series.

Jennifer M Scarce is Curator of the Oriental Collections in the Royal Scottish Museum. Her publications include articles on Persian and Turkish Costume, and late Persian tilework. She has arranged several exhibitions on these themes for the Royal Scottish Museum.

W Schomberg Scott has been a practising architect who was architectural adviser to the National Trust for Scotland from 1962 to 1971. He was involved with a number of projects for the Trust, especially the information centres at Killiecrankie, Falkland and Inverewe, and reconstructed the Queen Anne wing at Crathes in 1967.

Basil Skinner was for twelve years Assistant Keeper in Scottish National Portrait Gallery and is now director of Extra-Mural Studies in Edinburgh University. He arranged such exhibitions as *Scots in Italy in the Eighteenth Century*, and the *Sir Walter Scott Bicentenary* and wrote the catalogues. He served for five years on the Council of the National Trust for Scotland.

Margaret Swain has for many years studied the history of textiles and textile furnishings and written on the subject for *The Burlington Magazine* and *The Connoisseur*. She is an honorary consultant to the Royal Scottish Museum and lectures widely in Britain and North America.

David Walker is a Principal Inspector with the Scottish Development Department. He was the joint author of *The Architecture of Glasgow* (1968) and contributed to *Seven Victorian Architects* (1976).

Printed in Scotland for Her Majesty's Stationery Office
by Pillans & Wilson Ltd. Edinburgh
H.F.4129 Dd630478 C100 7/81